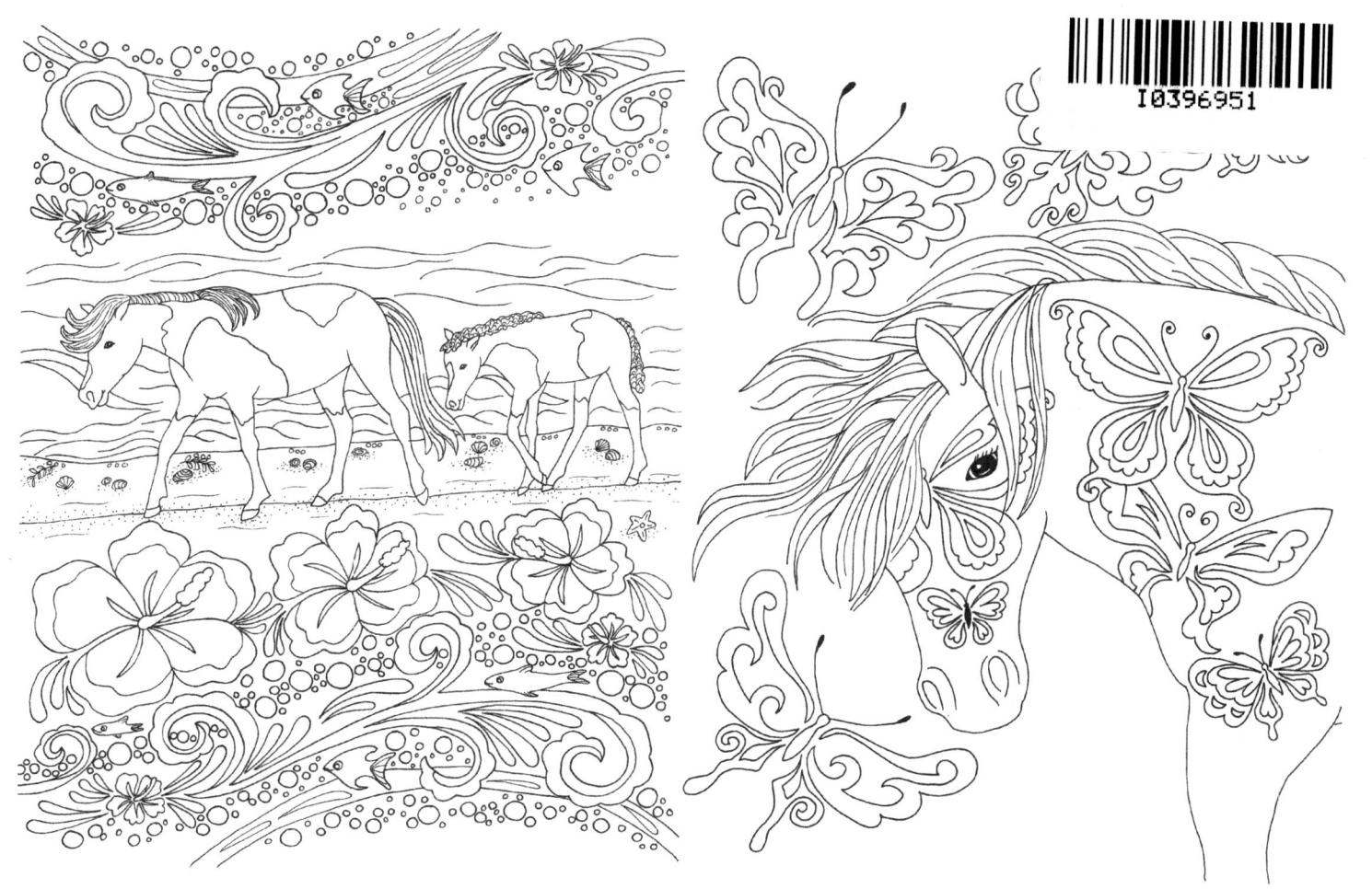

Wild Spirit Horse Coloring Book
The Horses of Assateague Island

Illustrations by Lynnette Jones

Dedication
For my husband and our daughters
I Love You!

Copyright 2017 Mrs. Lynnette Jones
www.MyArtByLynnette.biz LynnetteArt@gmail.com
All rights reserved

ISBN: 154514737X
ISBN-13: 978-1545147375

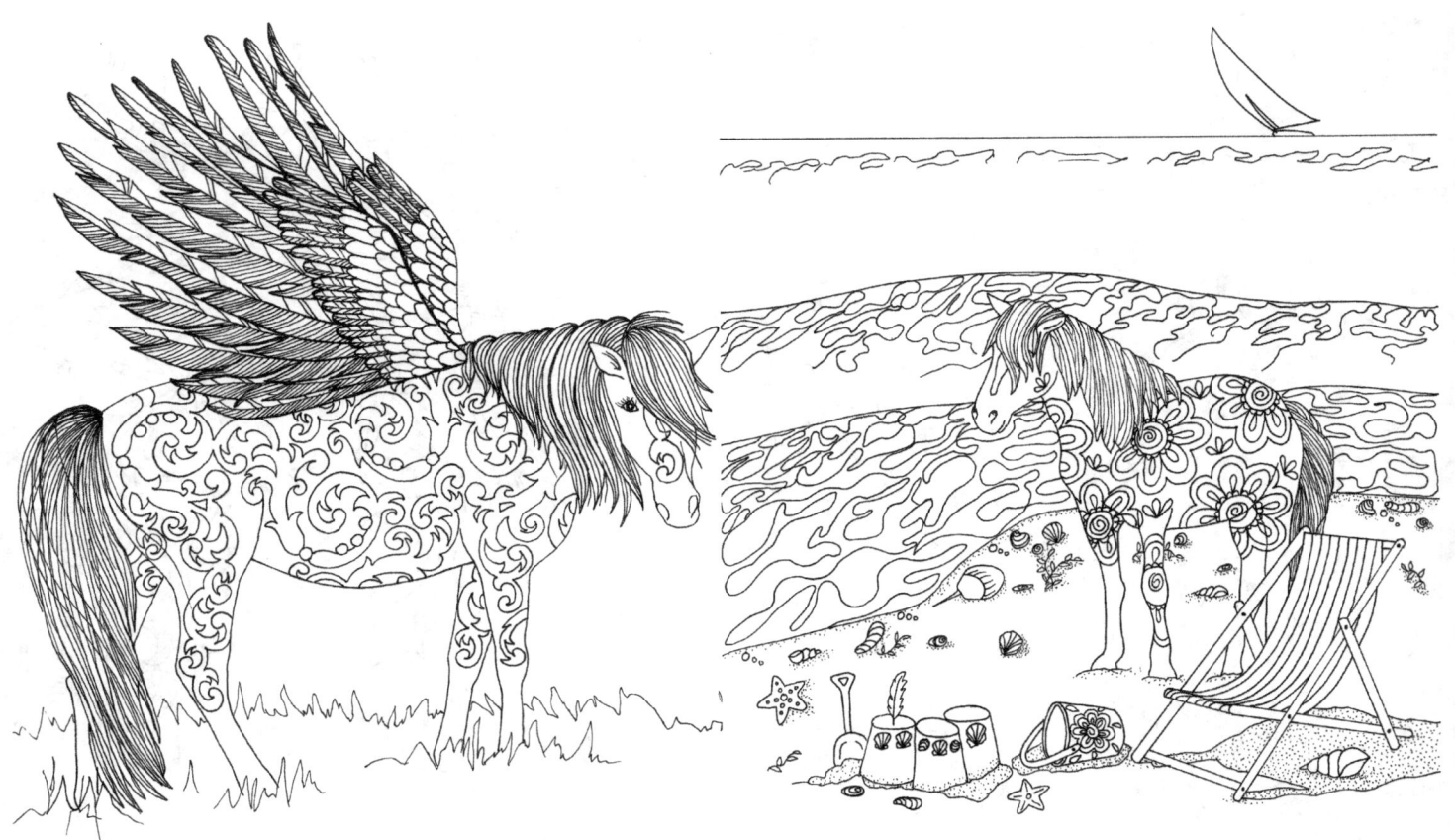

The spirit of the wild horses are alive and well in the State and National Parks of the United States. A herd of wild horses roam free on Assateague Island in Maryland, USA. Assateague Island is a barrier island bordered by the Atlantic Ocean on the east and the Sinepuxent Bay on the west. Historians say that the wild horses are descendants of horses that were brought to barrier islands in the late 17th century by mainland owners to avoid fencing laws and taxation of livestock. The wild horses are descendants of domestic animals that have reverted to a wild state.

I have spent many summers camping among the wild horses on Assateague Island. The horses in this coloring book are illustrated from photographs of these wild Assateague horses. If you visit Assateague Island, you can see the horses walking freely on the beach and splashing in the ocean. In the morning, the wild horses eat wild blackberries and beach grass that grow on the island. Baby horses are born in the early summer and newborn foals are watched over and protected by the whole herd. The wild horses are amazing gentle and curious creatures. I have turned my shoulder to find one of the horses has silently walked up to me to investigate the items on my picnic table. One mare walked right past me, so carefully as to not step on my bare feet and she swished a my leg with her long tail. Her gentle eyes, like a pool of water contained the whole depth of the ocean and looking into her eyes I saw myself reflected back at me. A reminder that every living being in nature is connected. The horse are still wild and unpredictable and at any moment can rear, kick and bite at people who offend them.

When I designed my illustrations I thought about, what if I was a Native American born in the 1700's and owned one of these wild spirit horses. How would I paint my horse for a ceremony? Would I put feathers, beads and shells in their mane or paint the horse's body for a special day? I had fun imagining what if there really are wild spirit horses with a unicorn horn or wings like an eagle. Perhaps there is a real dream catcher horse that visits humans at night to catch all the bad dreams and deliver sweet dreams to all.

Now you too can imagine to own one of these wild spirit horses that roam the wild lands in America's State and National Parks and color your horse any way that you desire. Please email me a photo of your coloring to MyArtByLynnette@yahoo.com and I will add your coloring page to my blog.

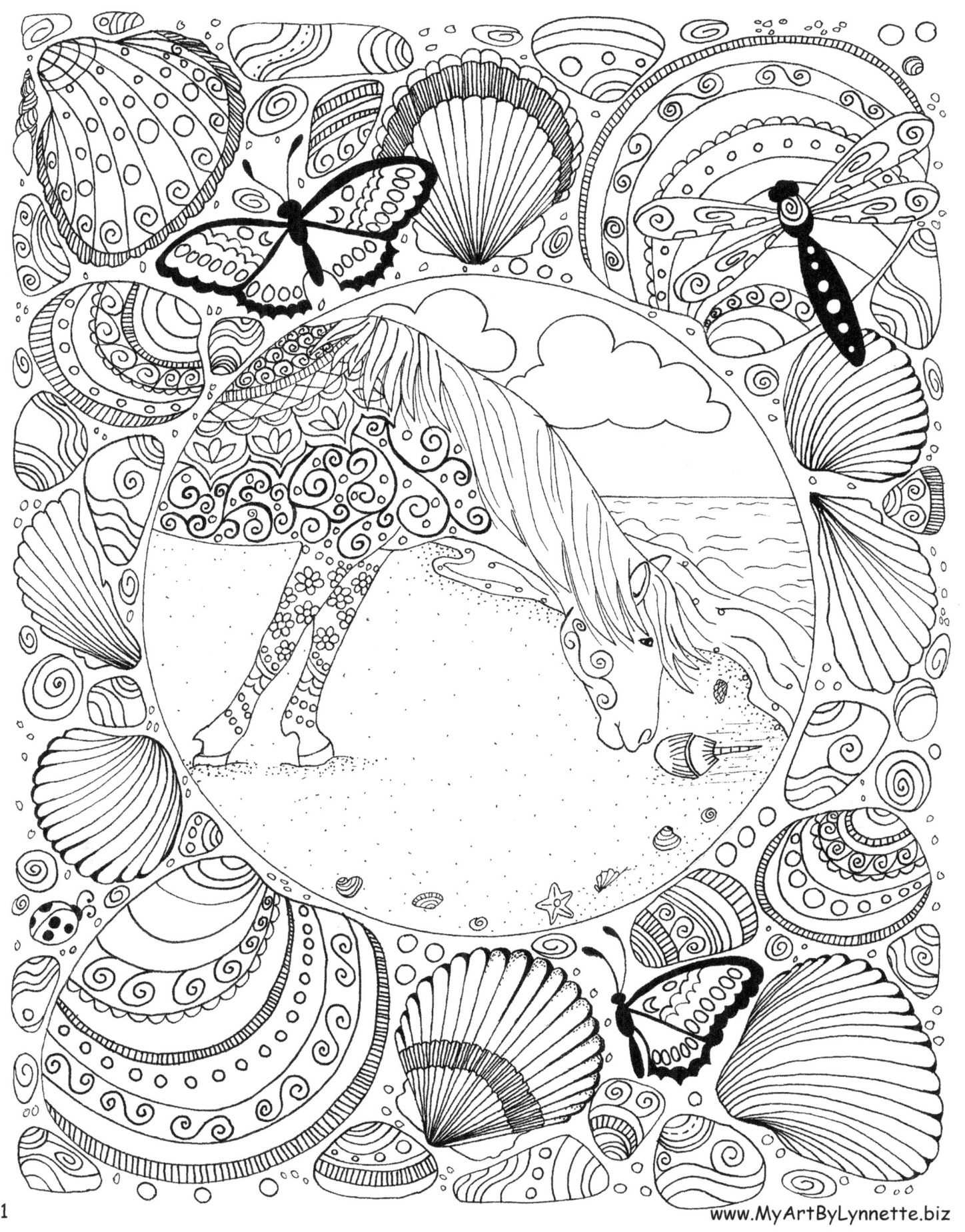

www.MyArtByLynnette.biz

It's

Never too

Late to Dream

Another Dream

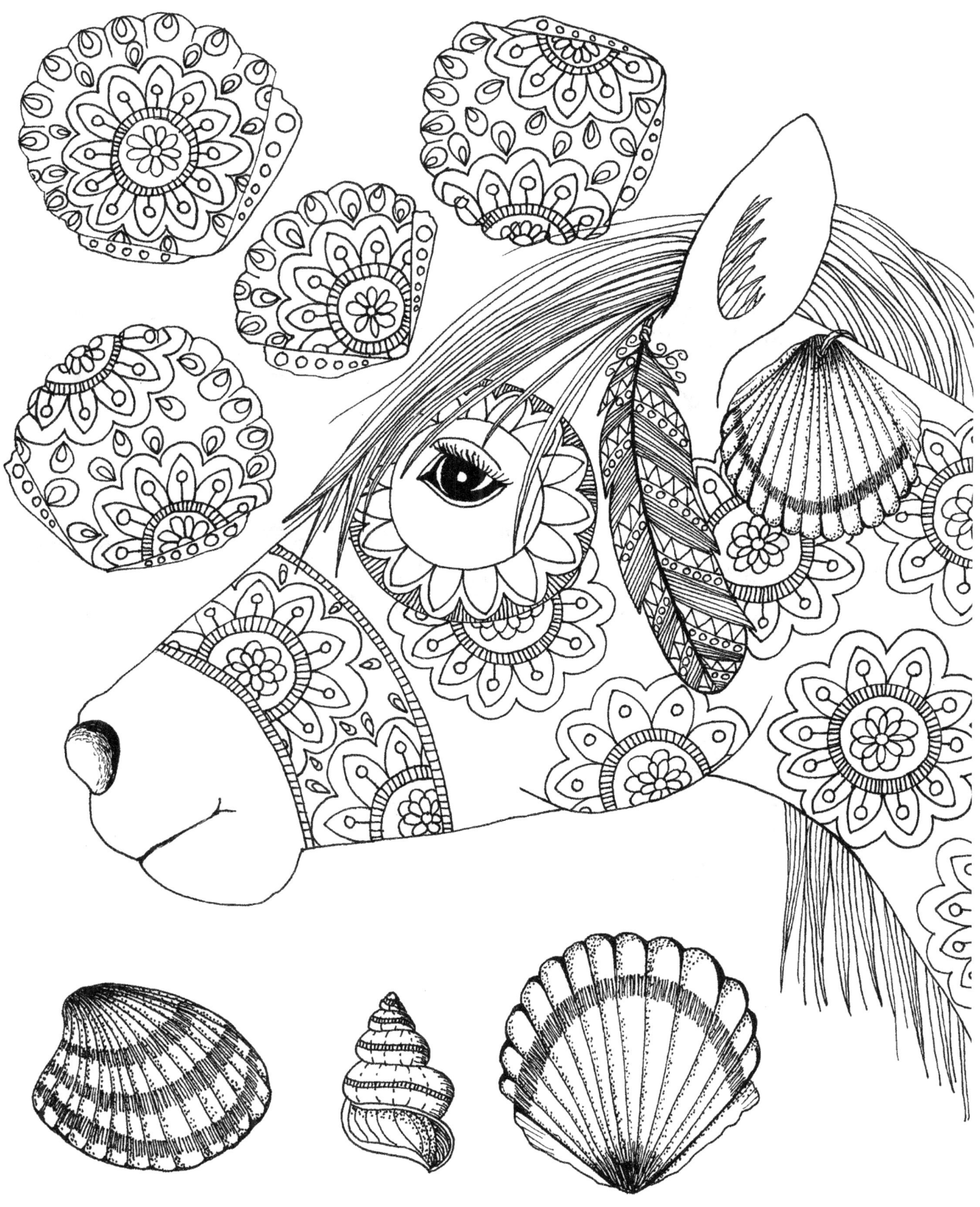

Horses are Forever in My Heart

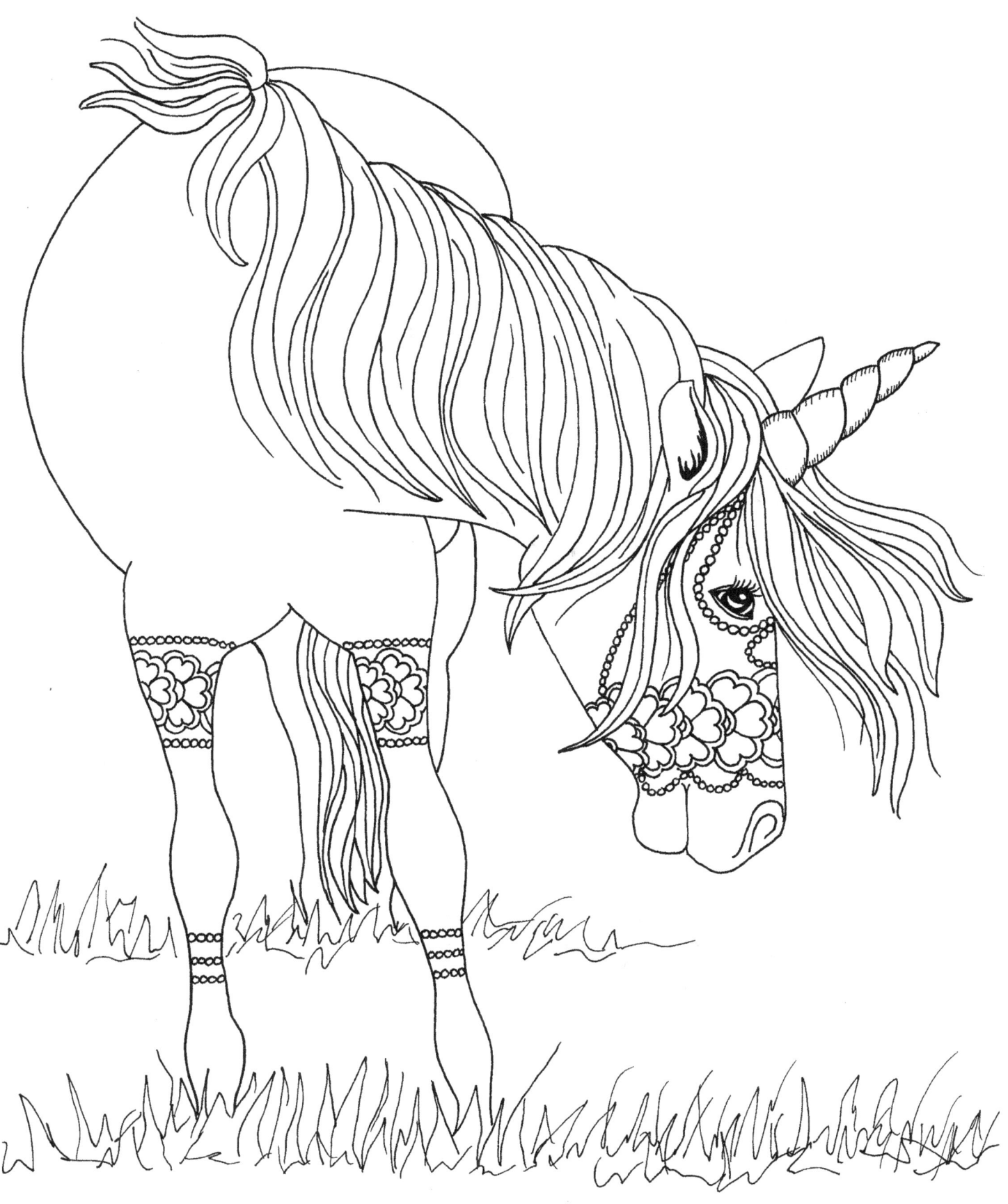

What if I Fall.
Oh, but what
if
you Fly!

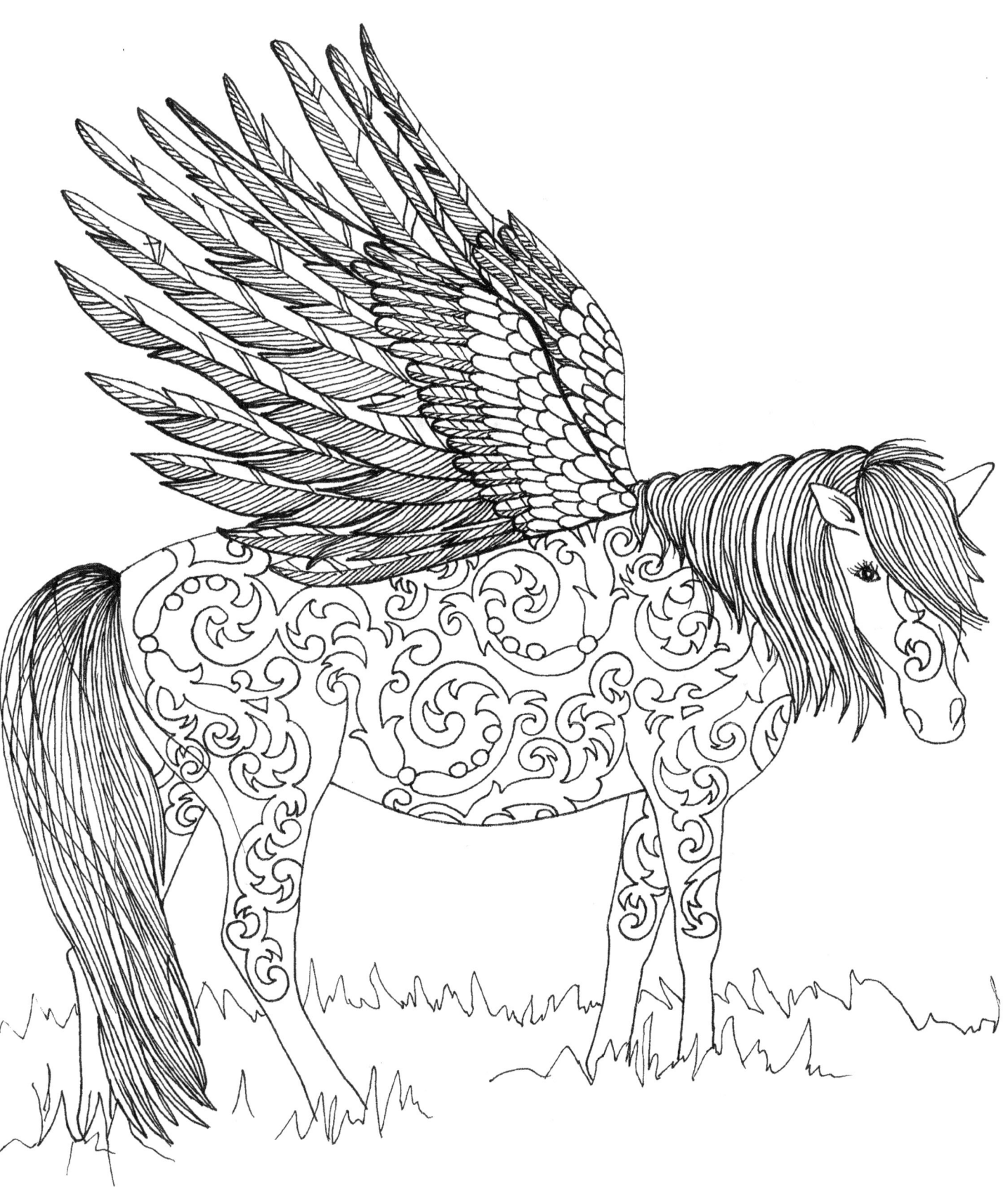

Your Best Freind doesn't always have to be a Human.

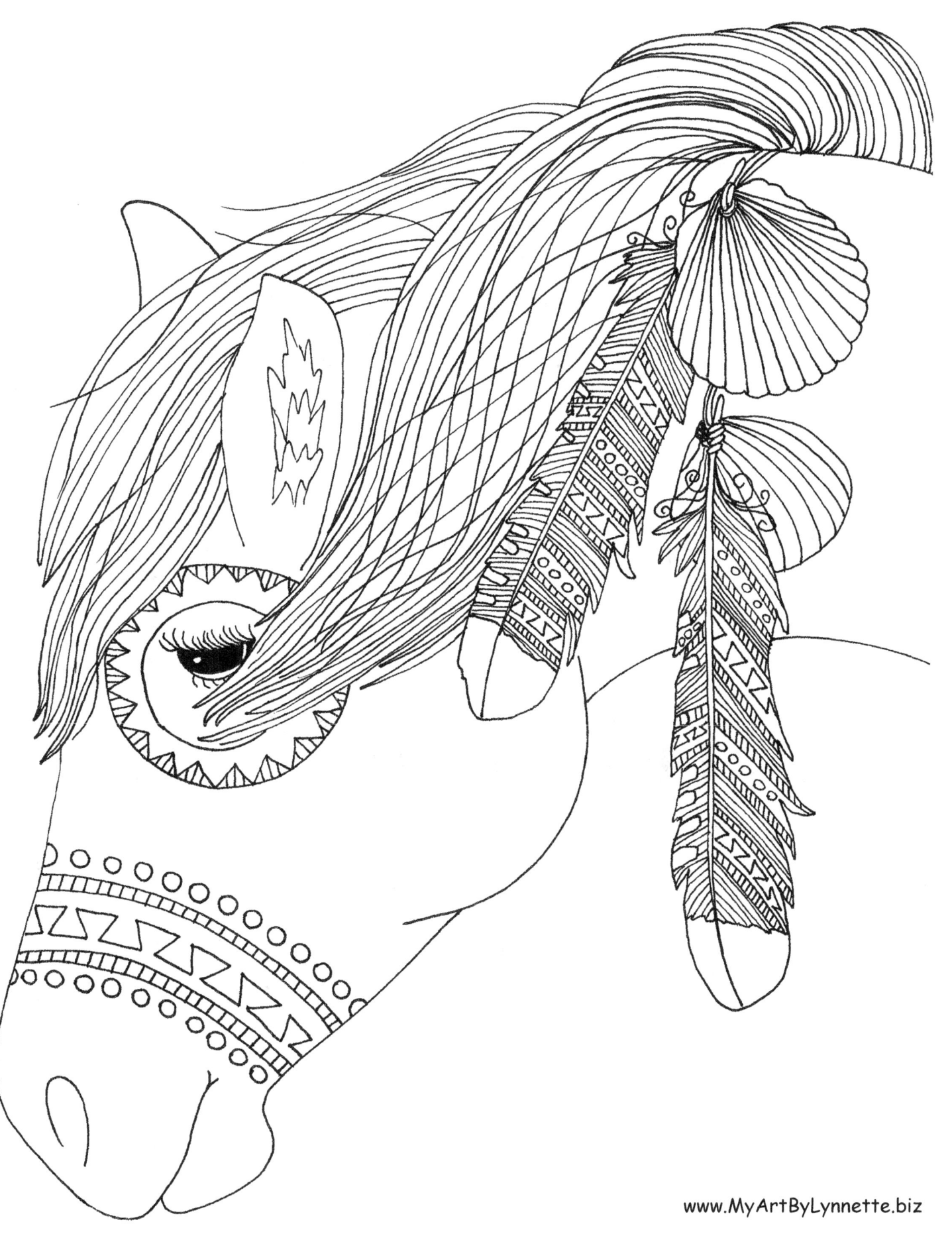

Start collecting memories not things!

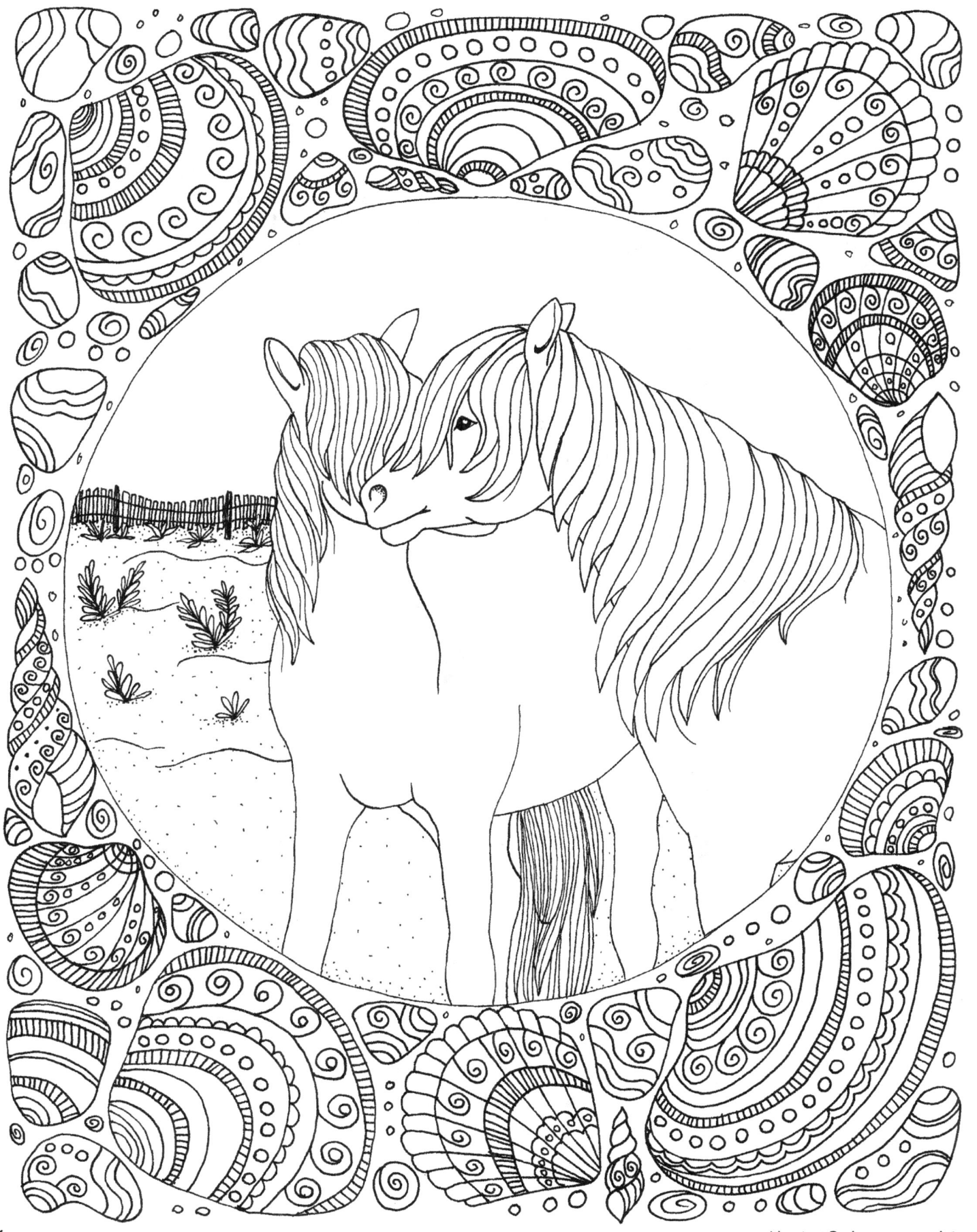

You are Smart.
You are Important.
You are Precious!

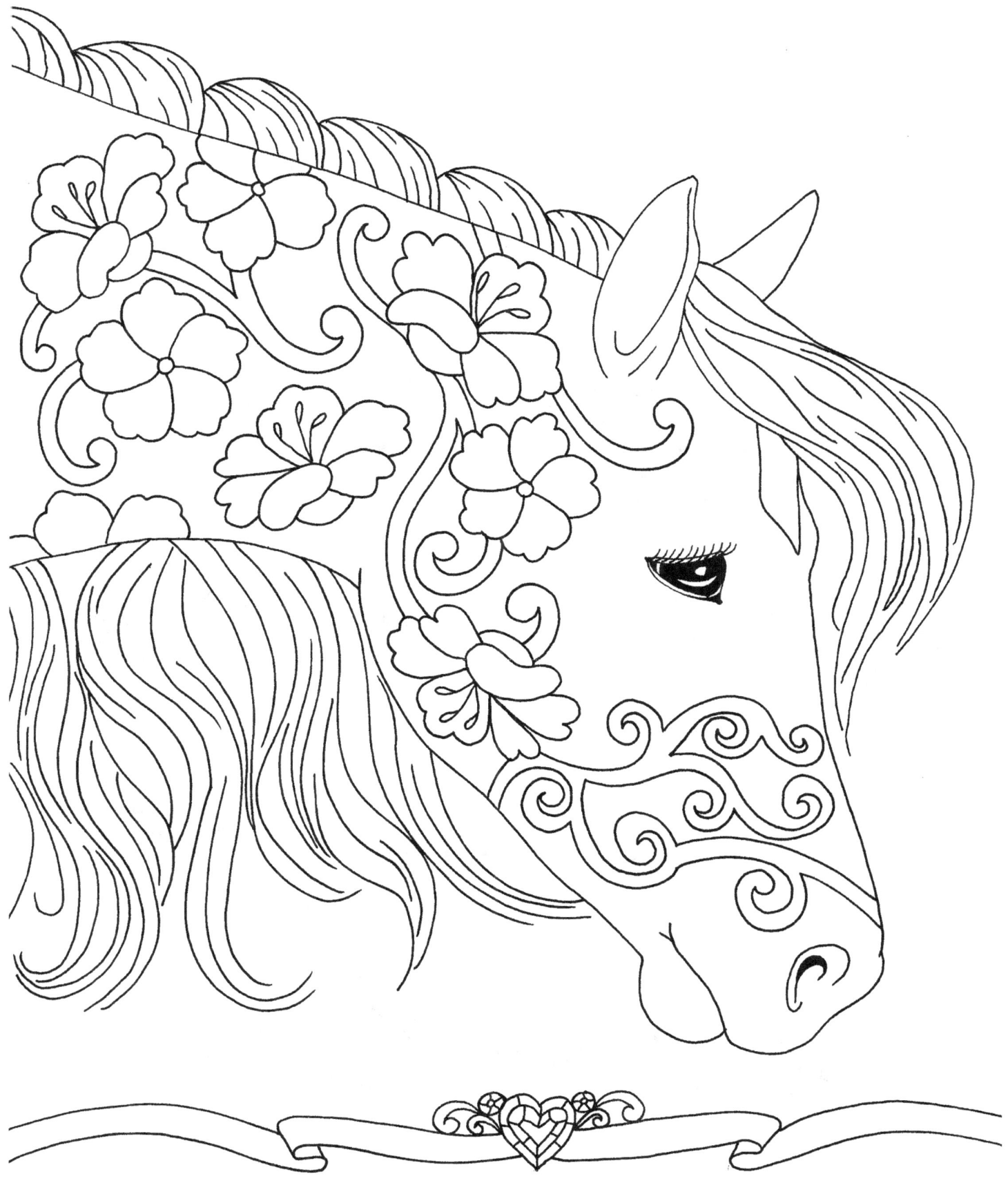

Travel Off the Beaten Path, Looking for Adventure

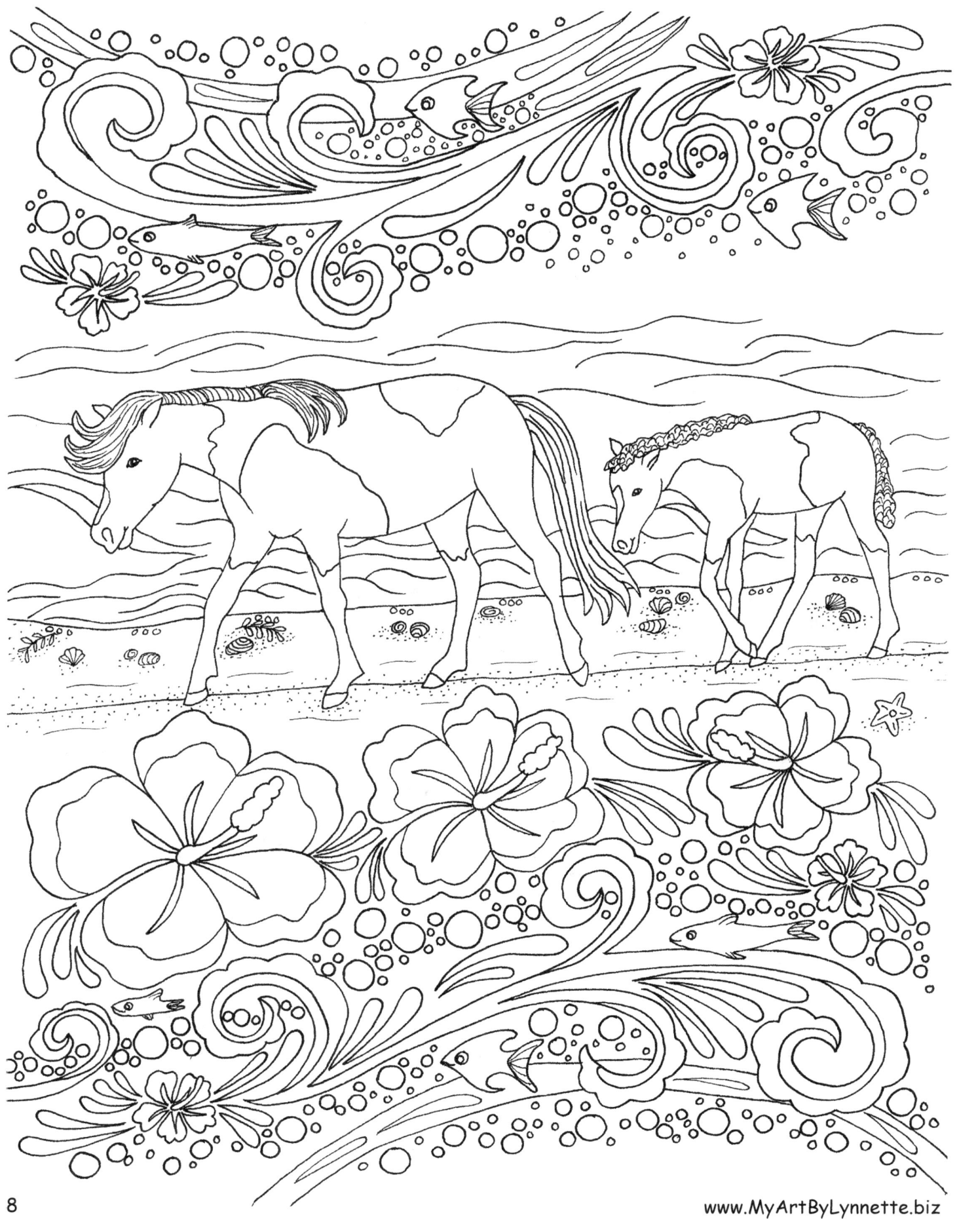

You are Fearless in the Face of any and all Challanges!

Born

Wild

Live Free

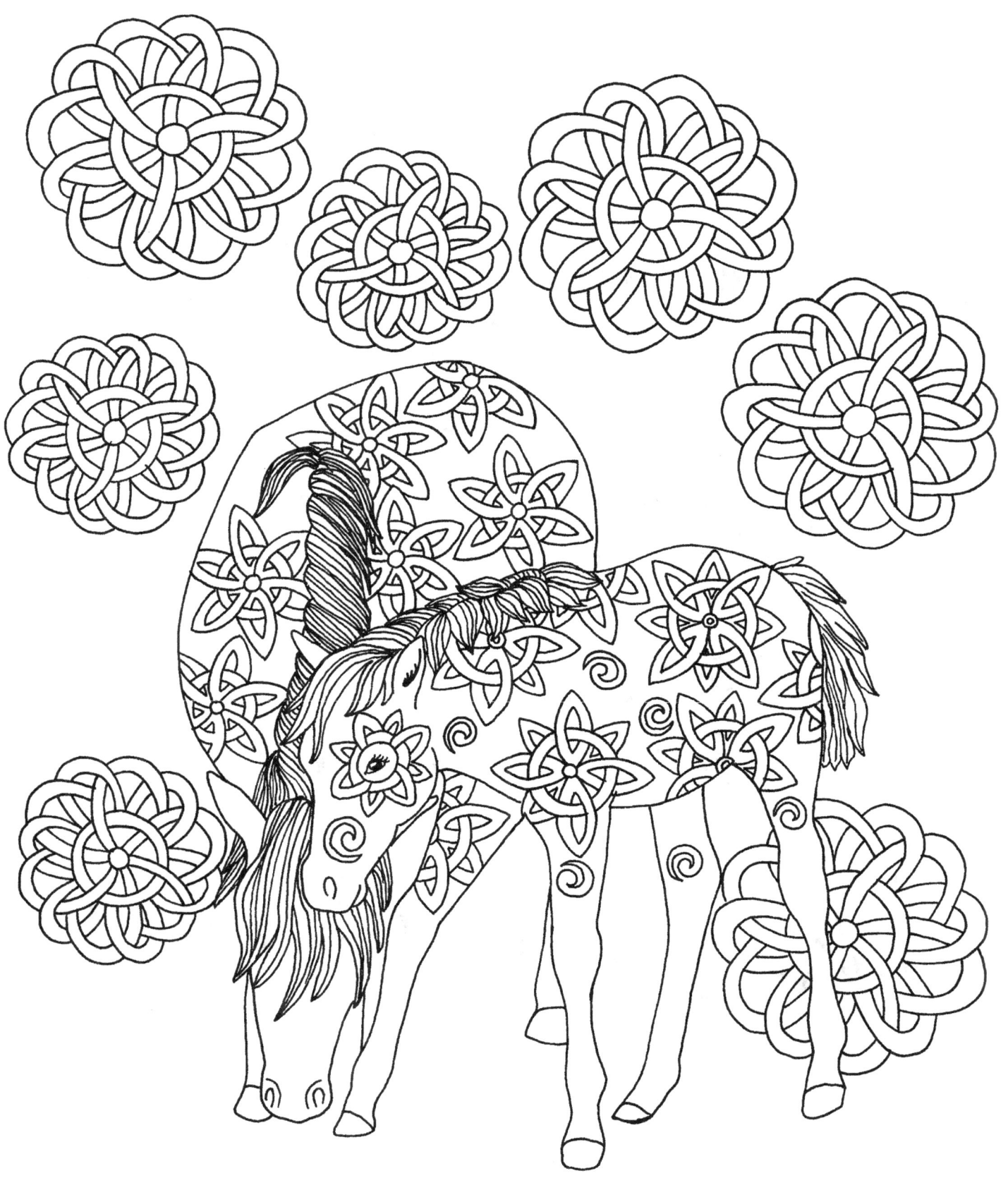

Live in the Sunshine, Dance in the Sea!

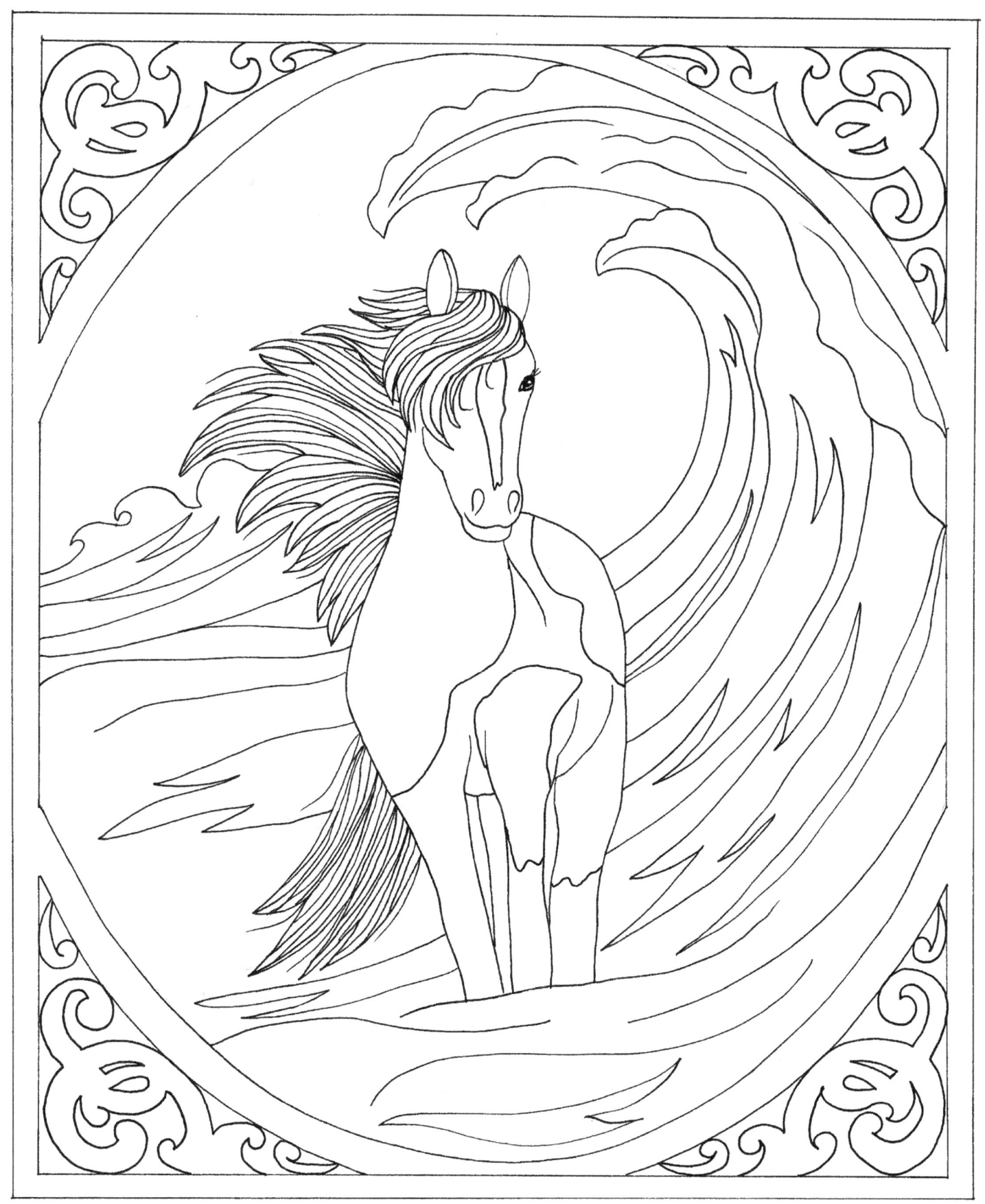

Run Wild until you find someone just as Wild to Run with!

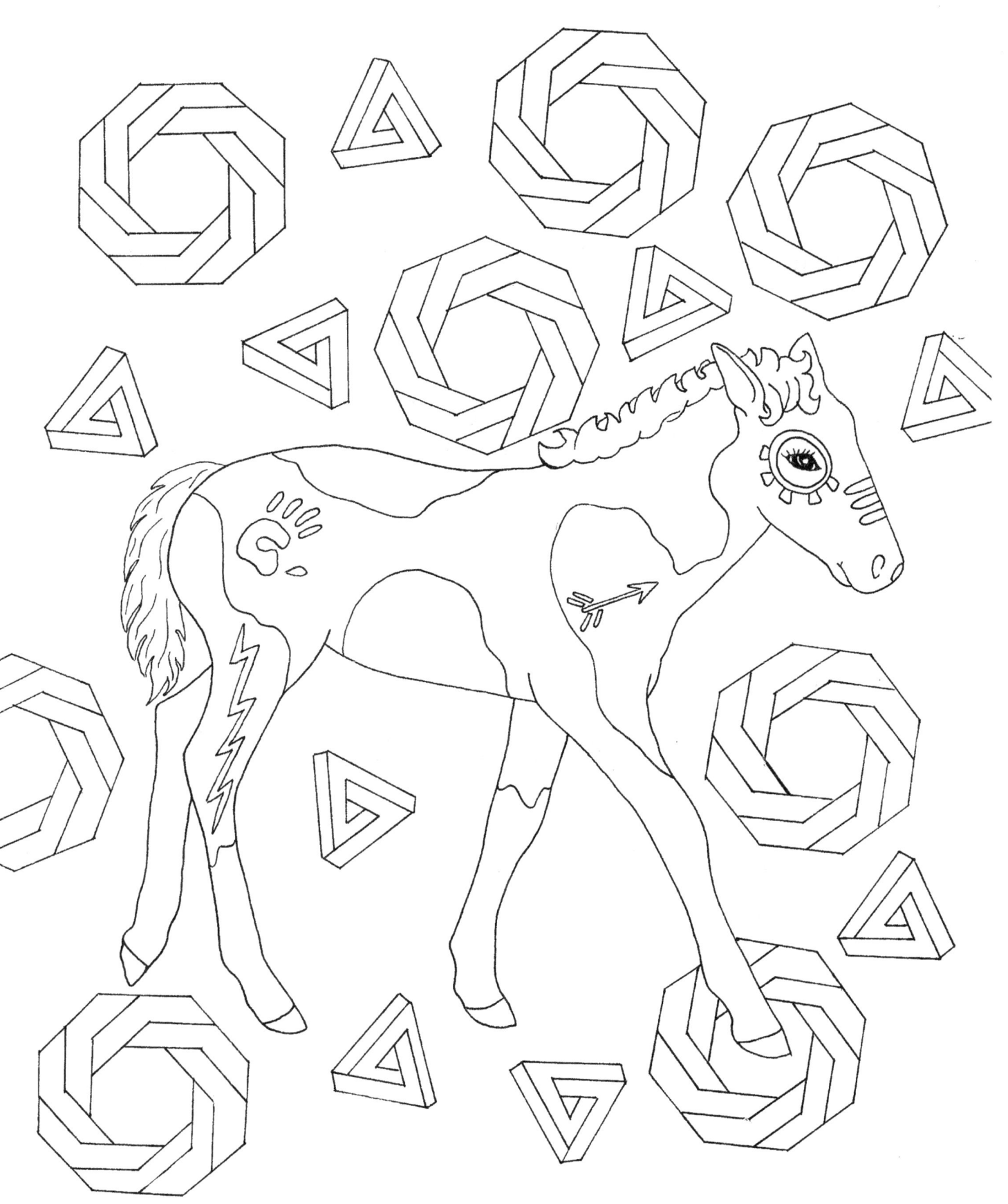

Horses are not my whole life...

Horses make my life whole.

The Nature of Life is to Grow

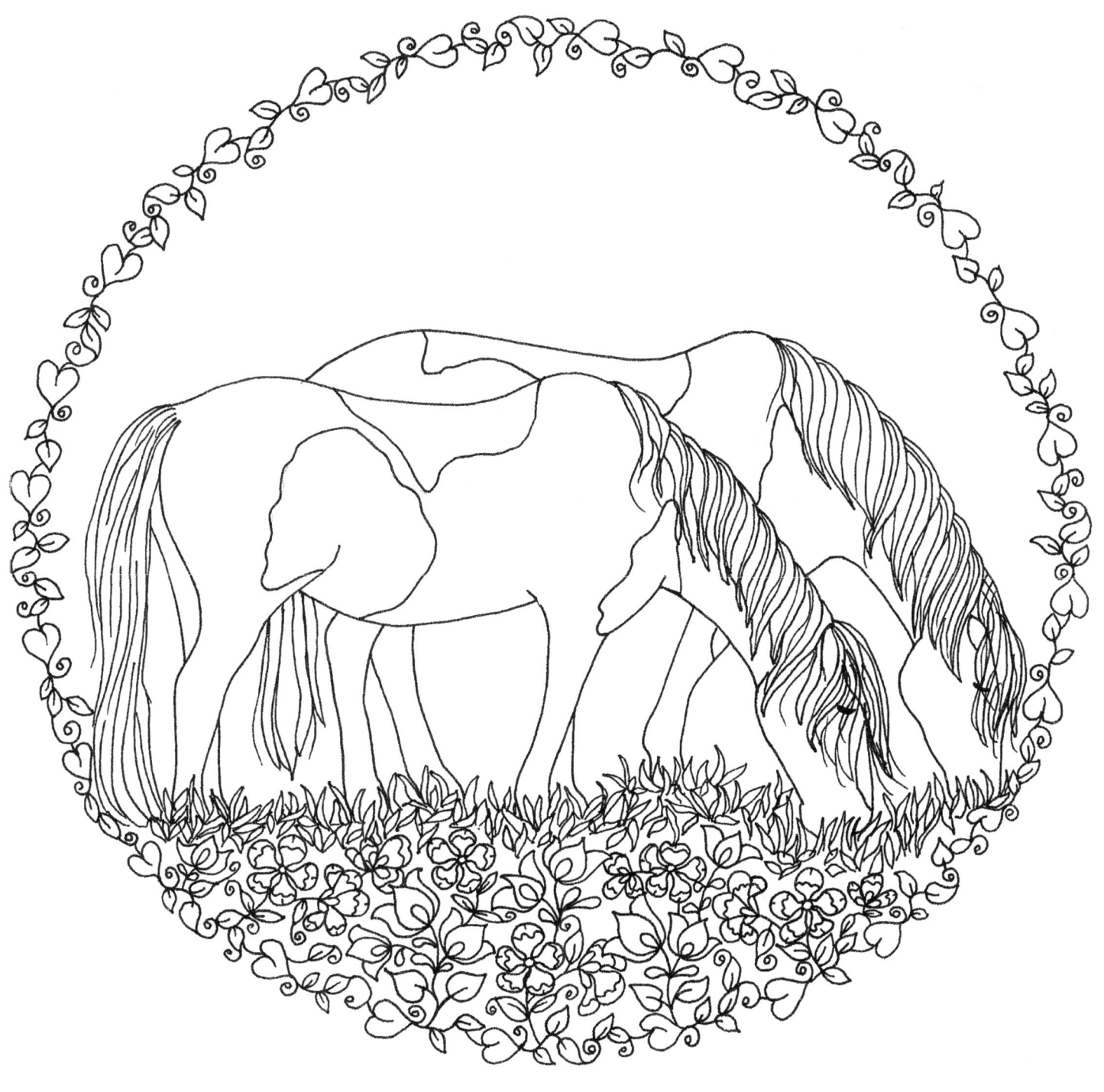

Walk Barefoot,

Listen to the Wind,

Run in the Moonlight,

Be Magical

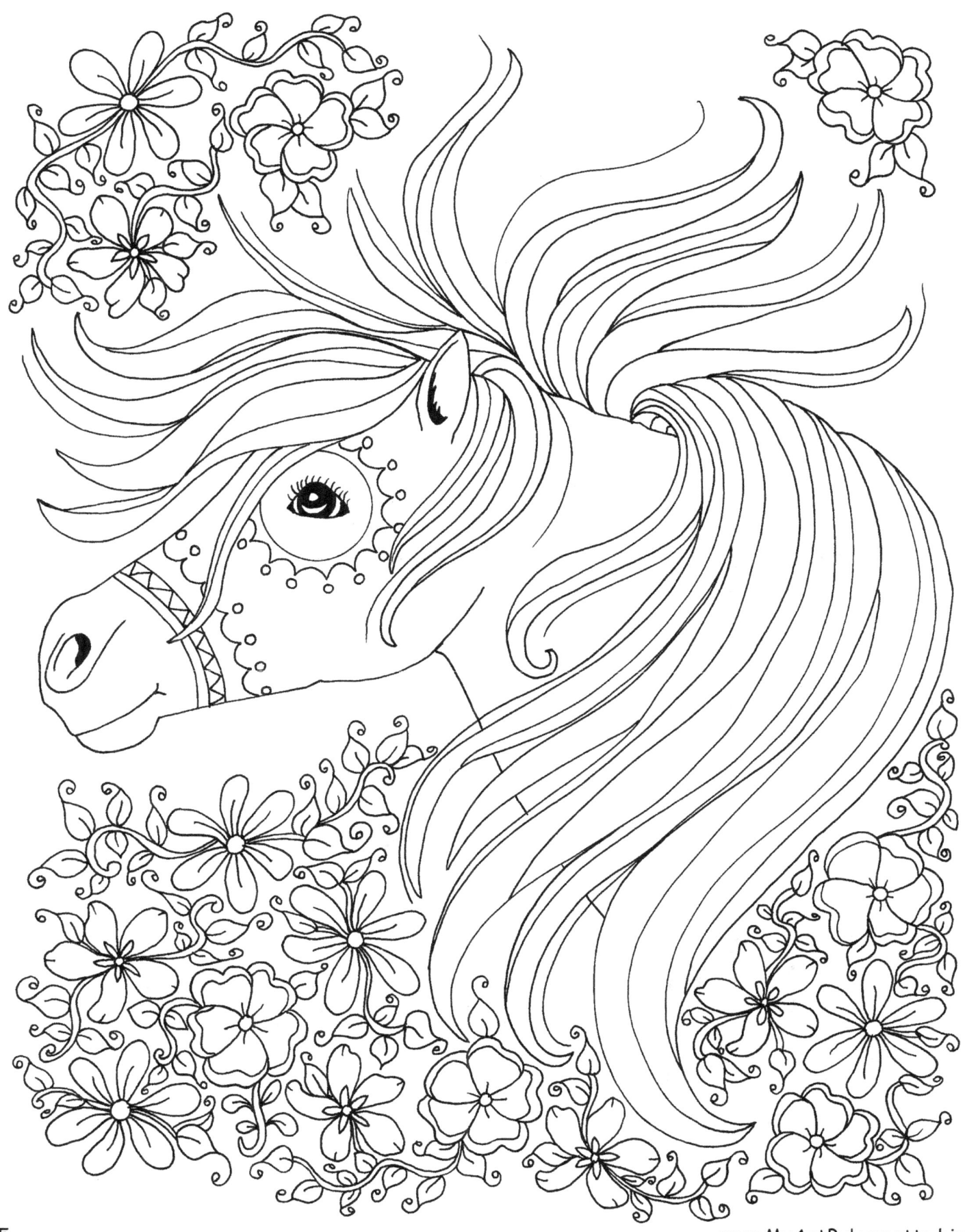

I'm just a free Spirit with a Wild Heart

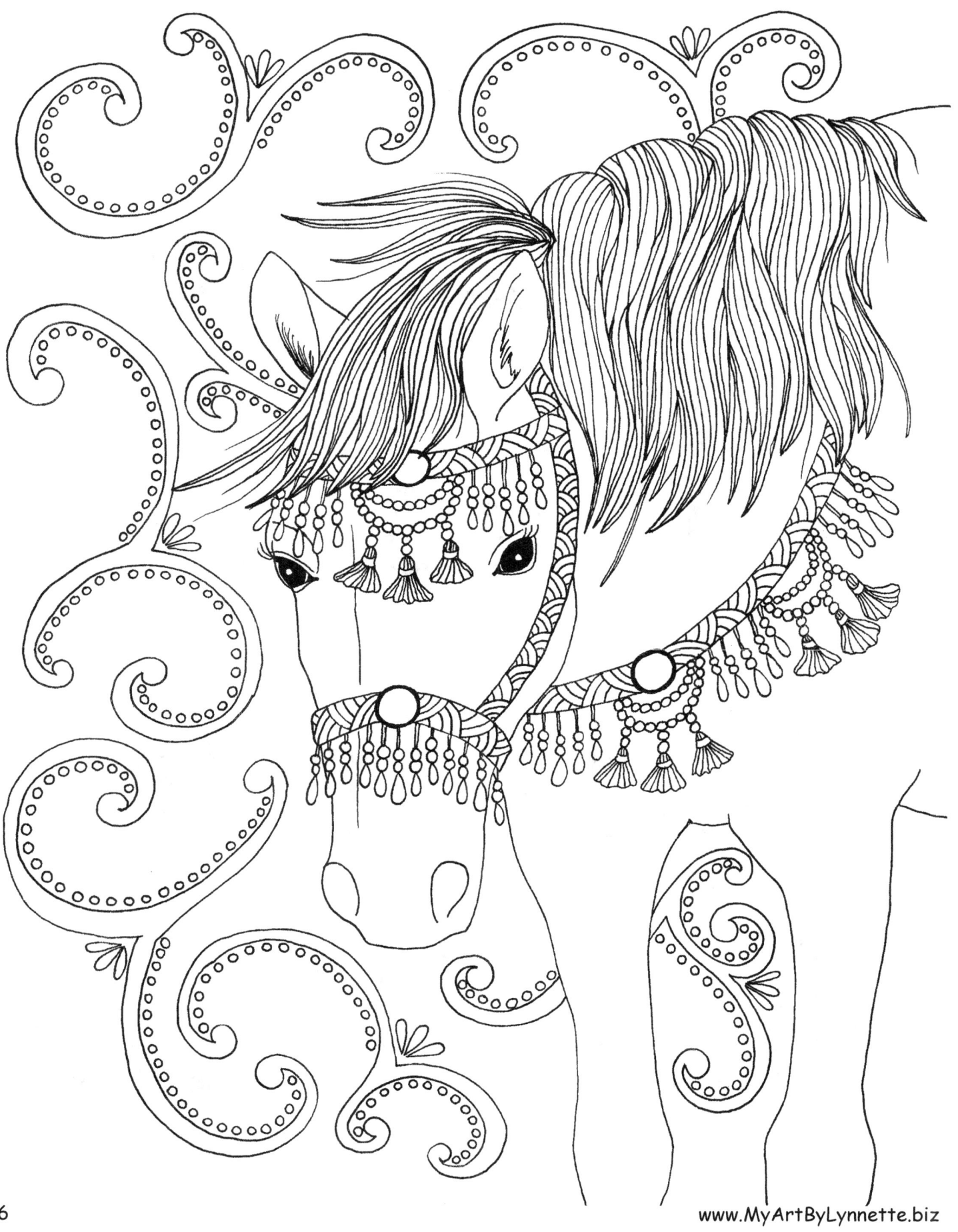

Love the Horses but leave them WILD

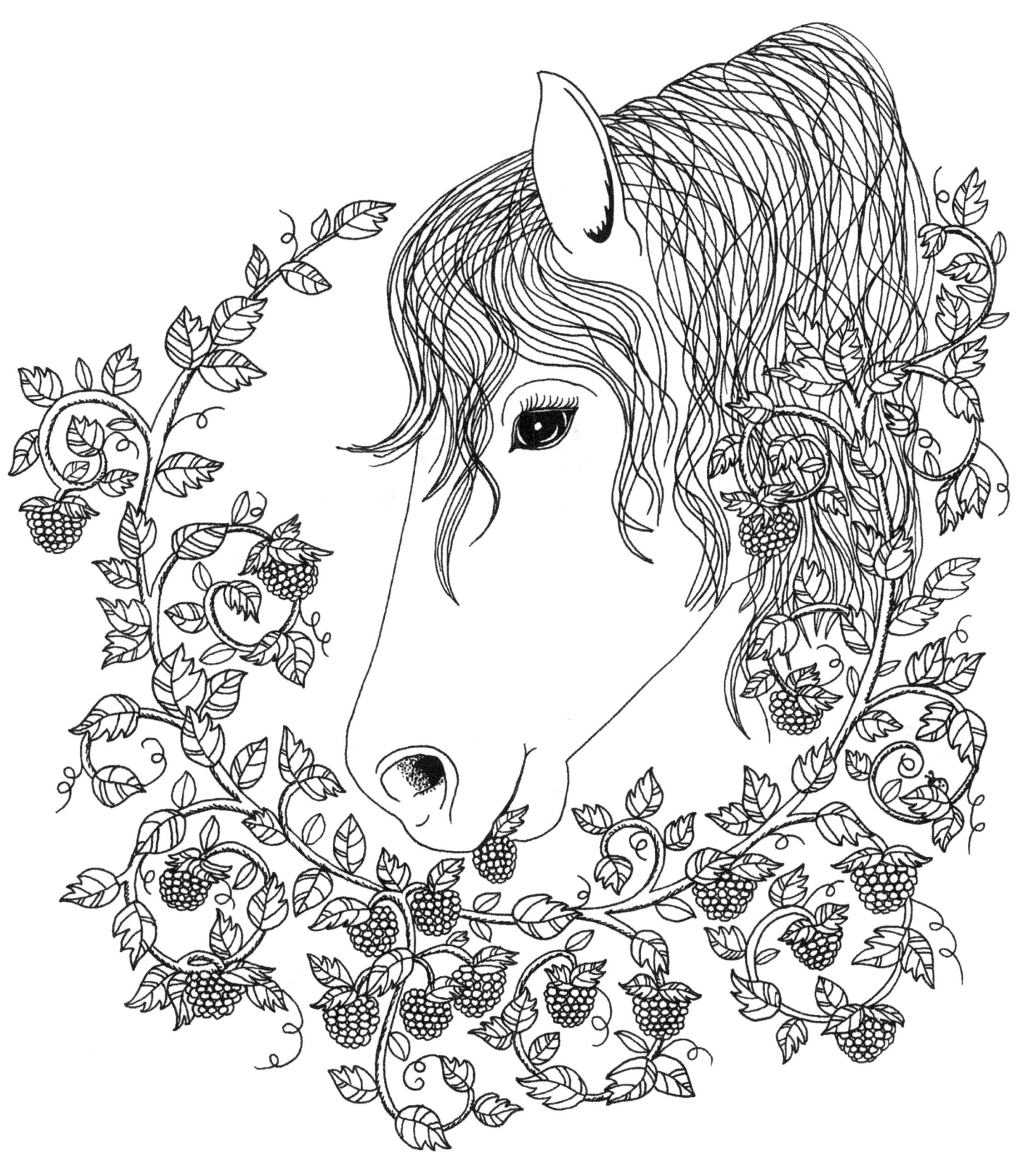

WILD THING

you make my Heart Sing

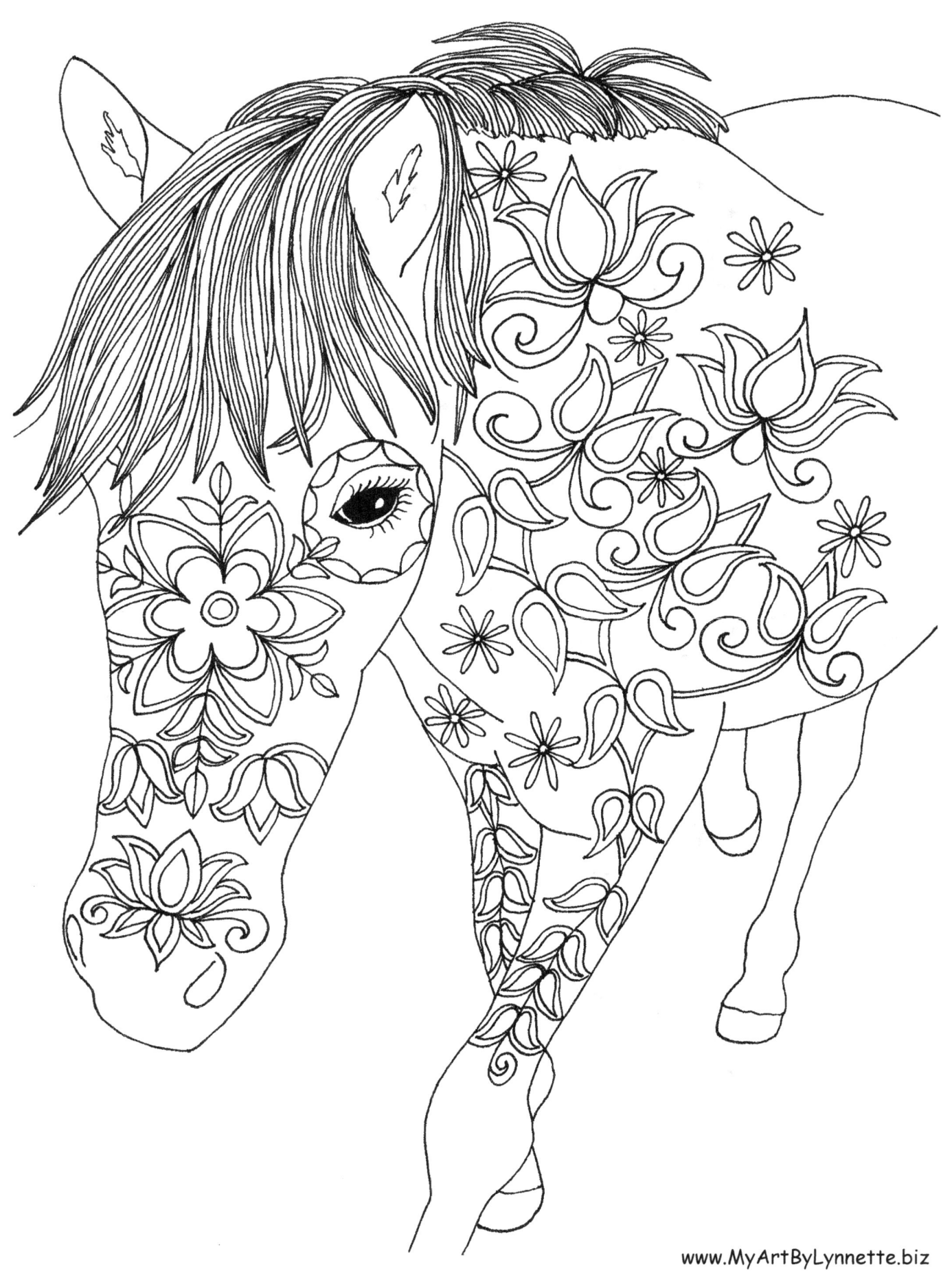

if you Love something set it FREE

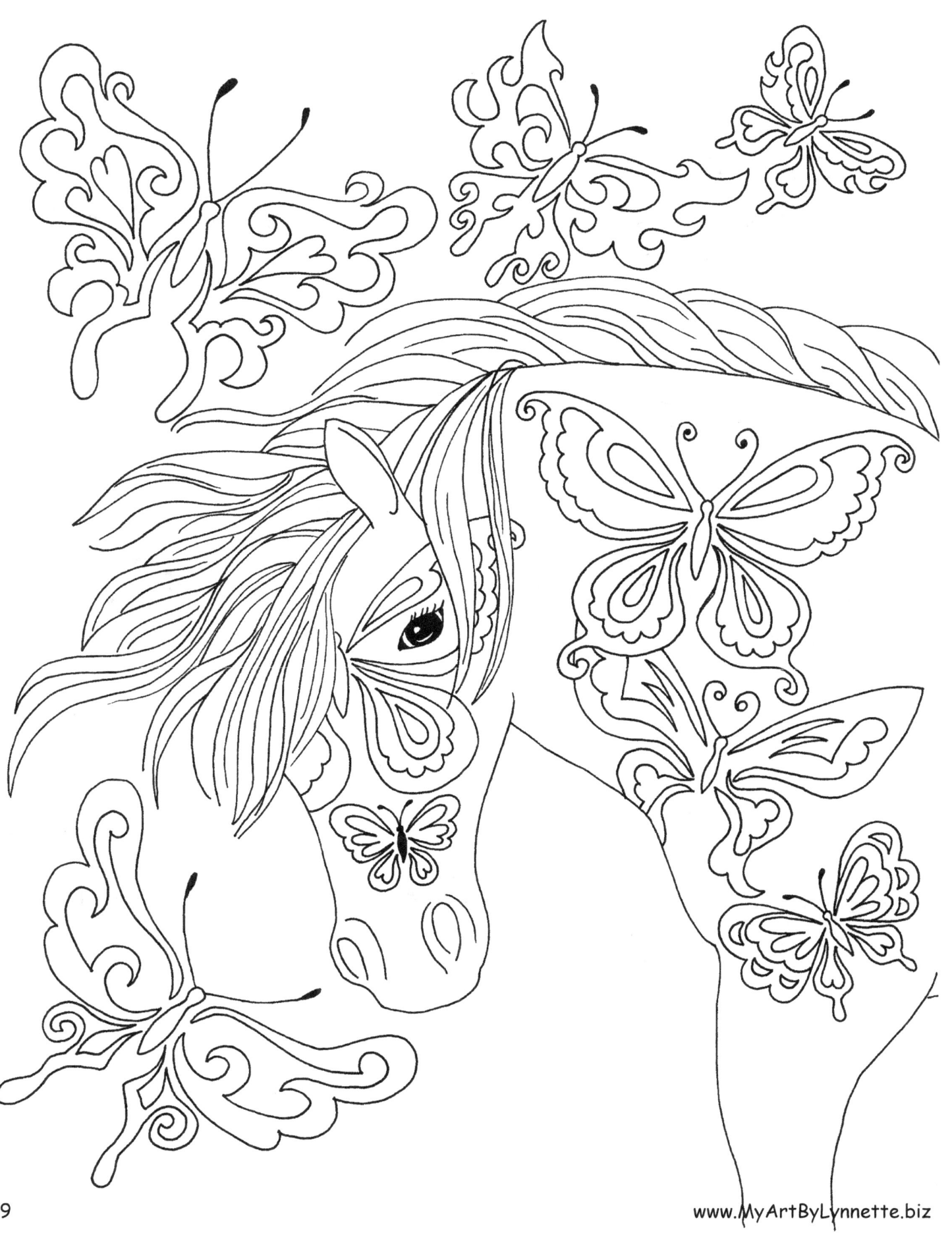

May my heart
be kind,
my mind fierce,
and
my spirit brave!

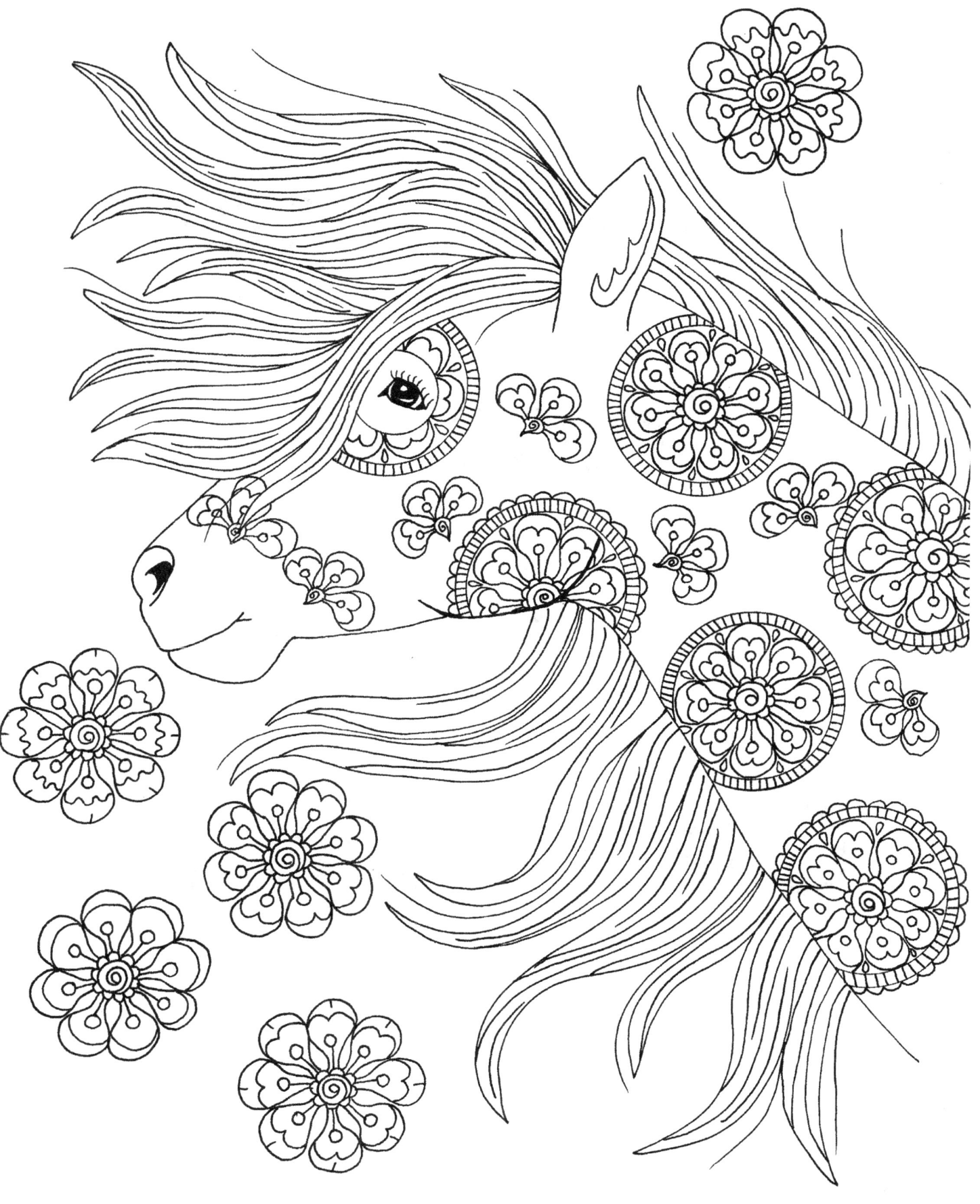

Live like someone left the Gate Open!

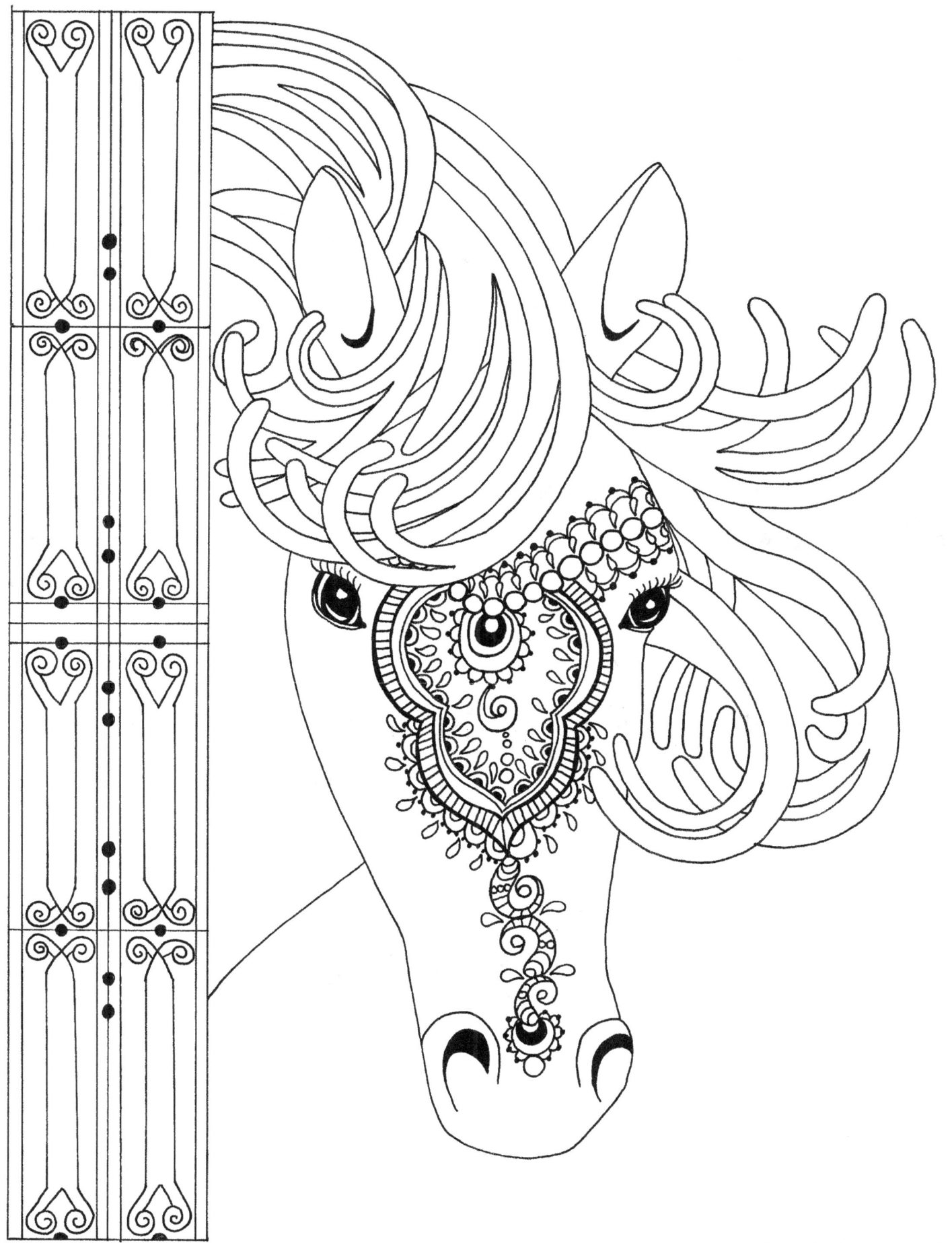

Balanced Rest and Activity are the keys to Success

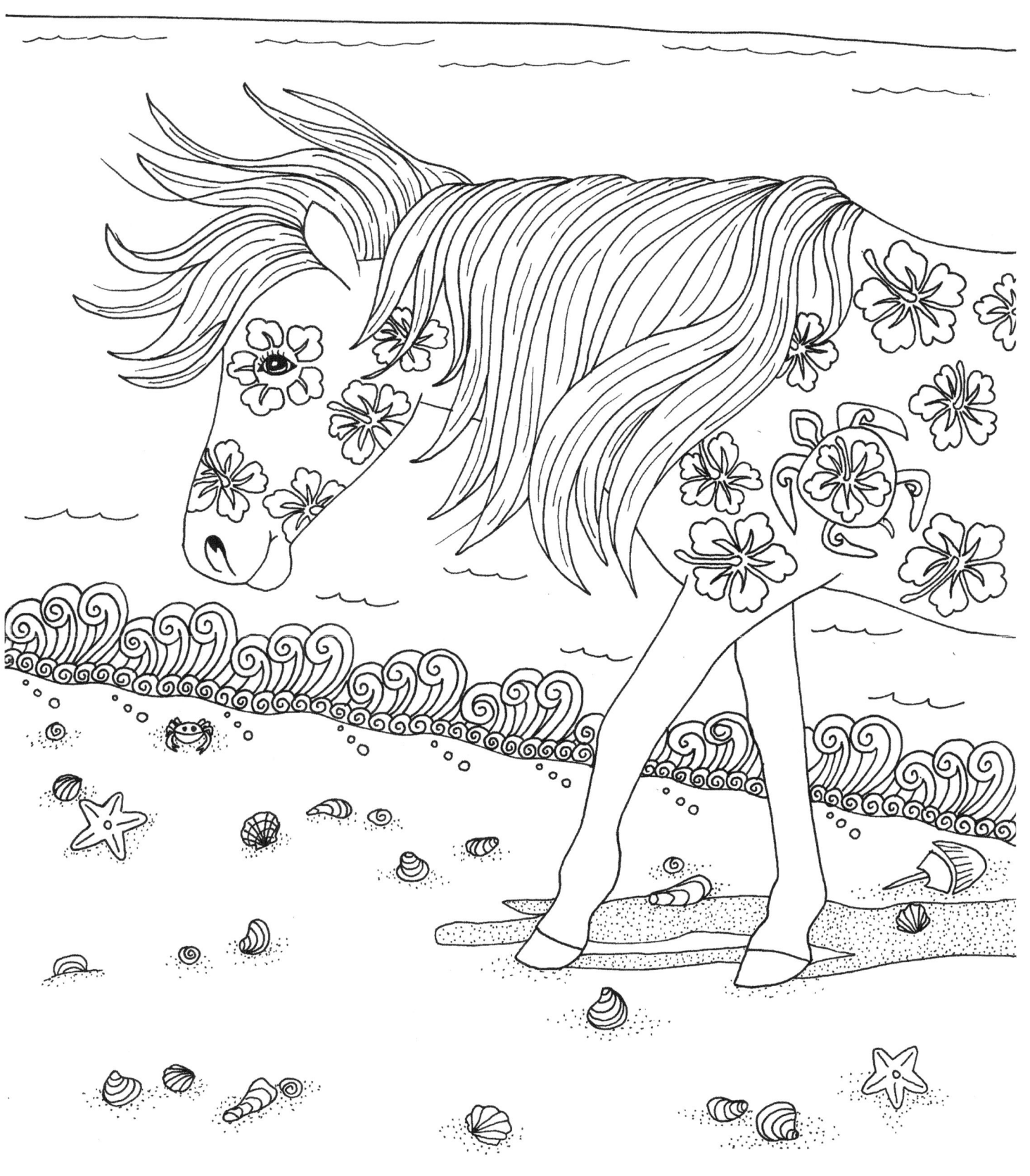

Sometimes you gotta

RUN

WILD &

FREE

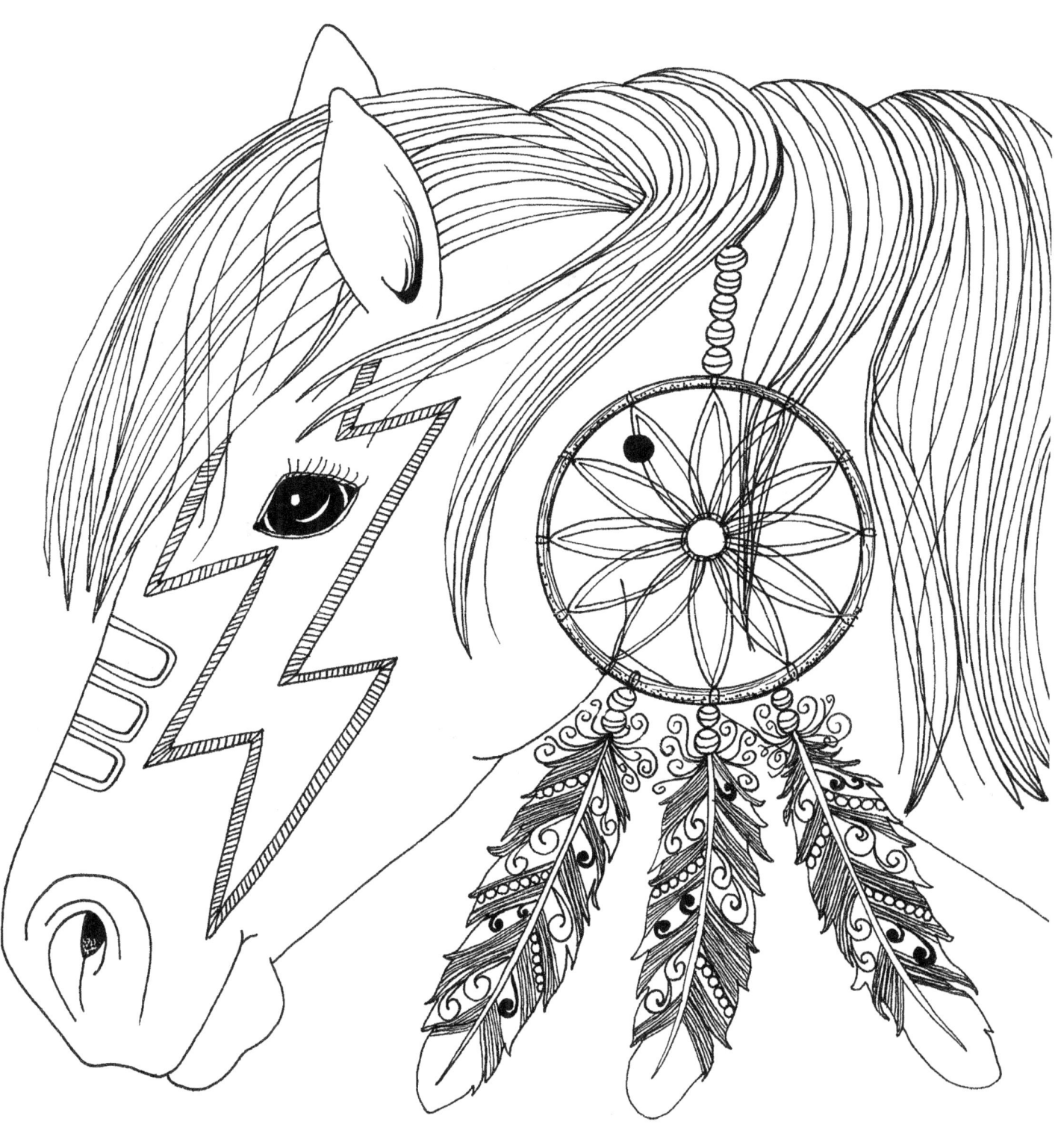

A Horse is poetry in motion!

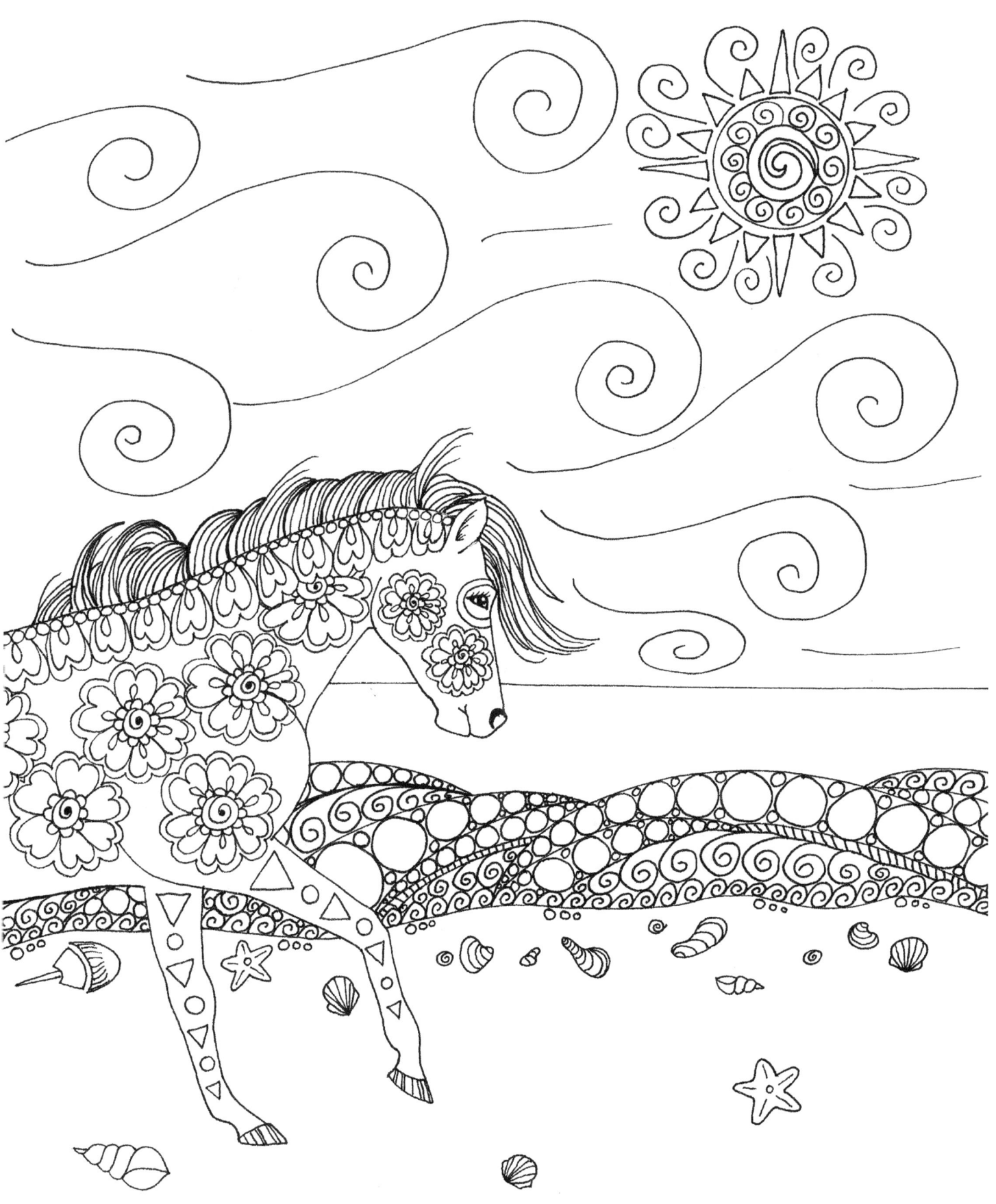

Harmony exixts in the diversity of **Nature**

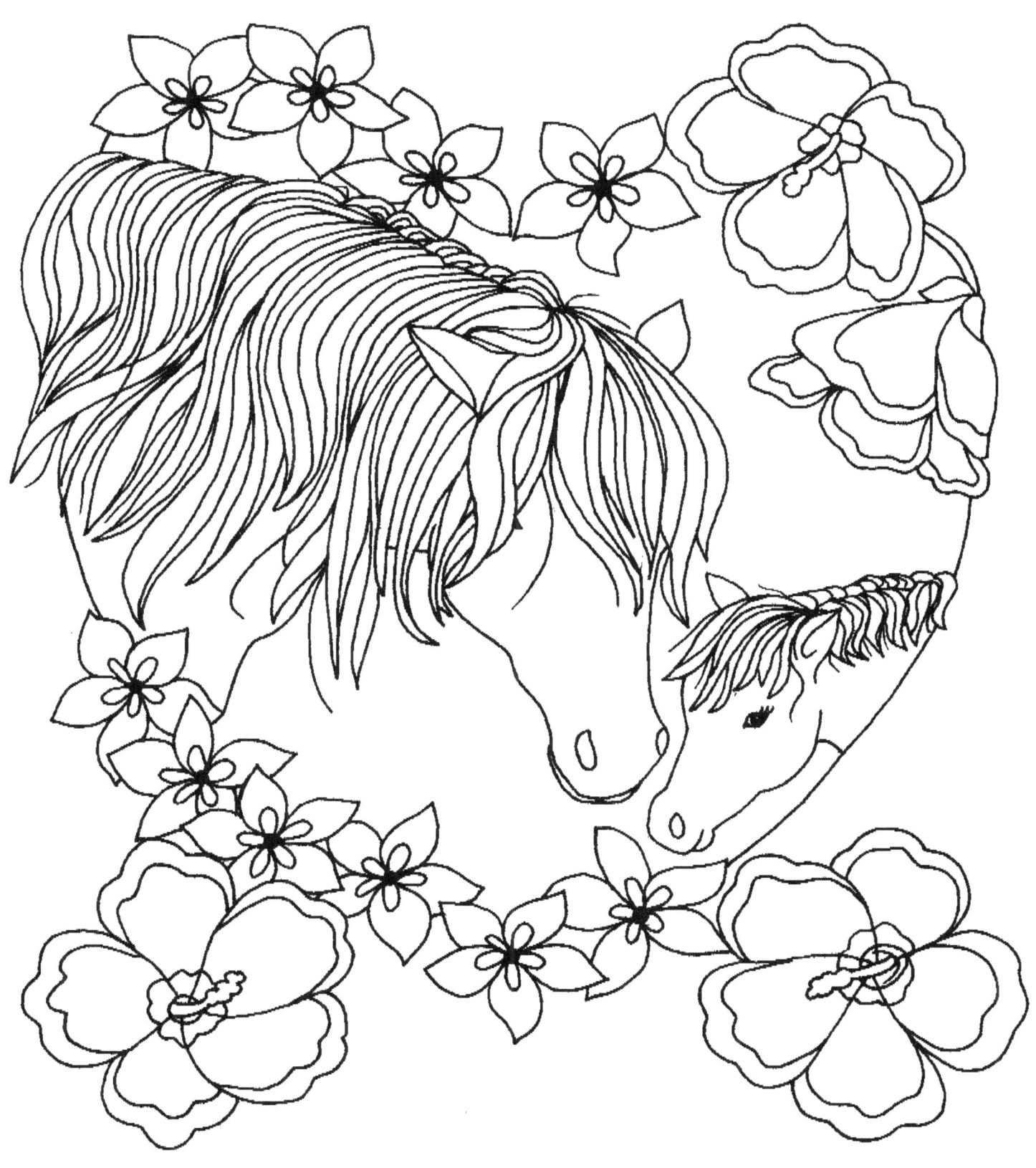

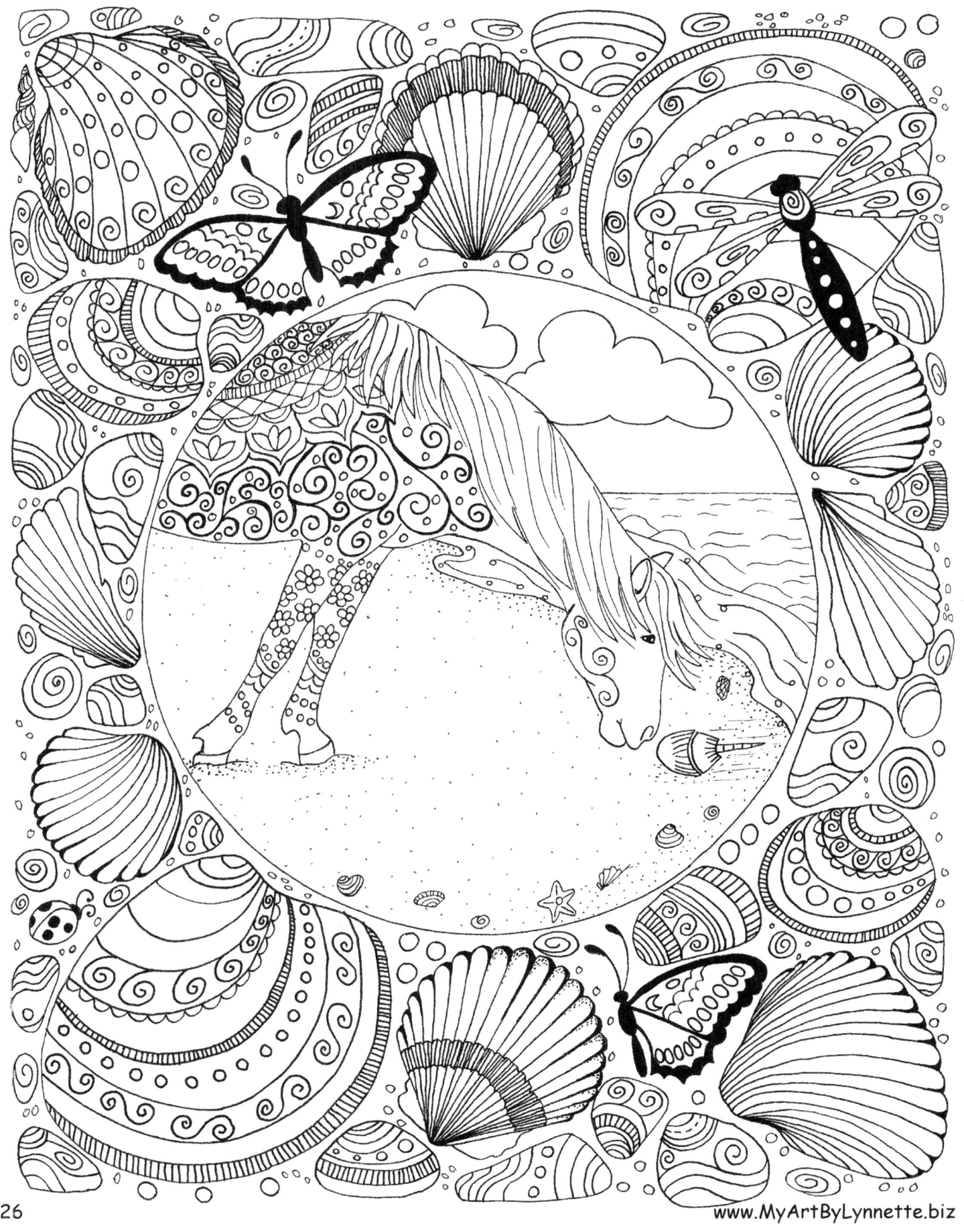

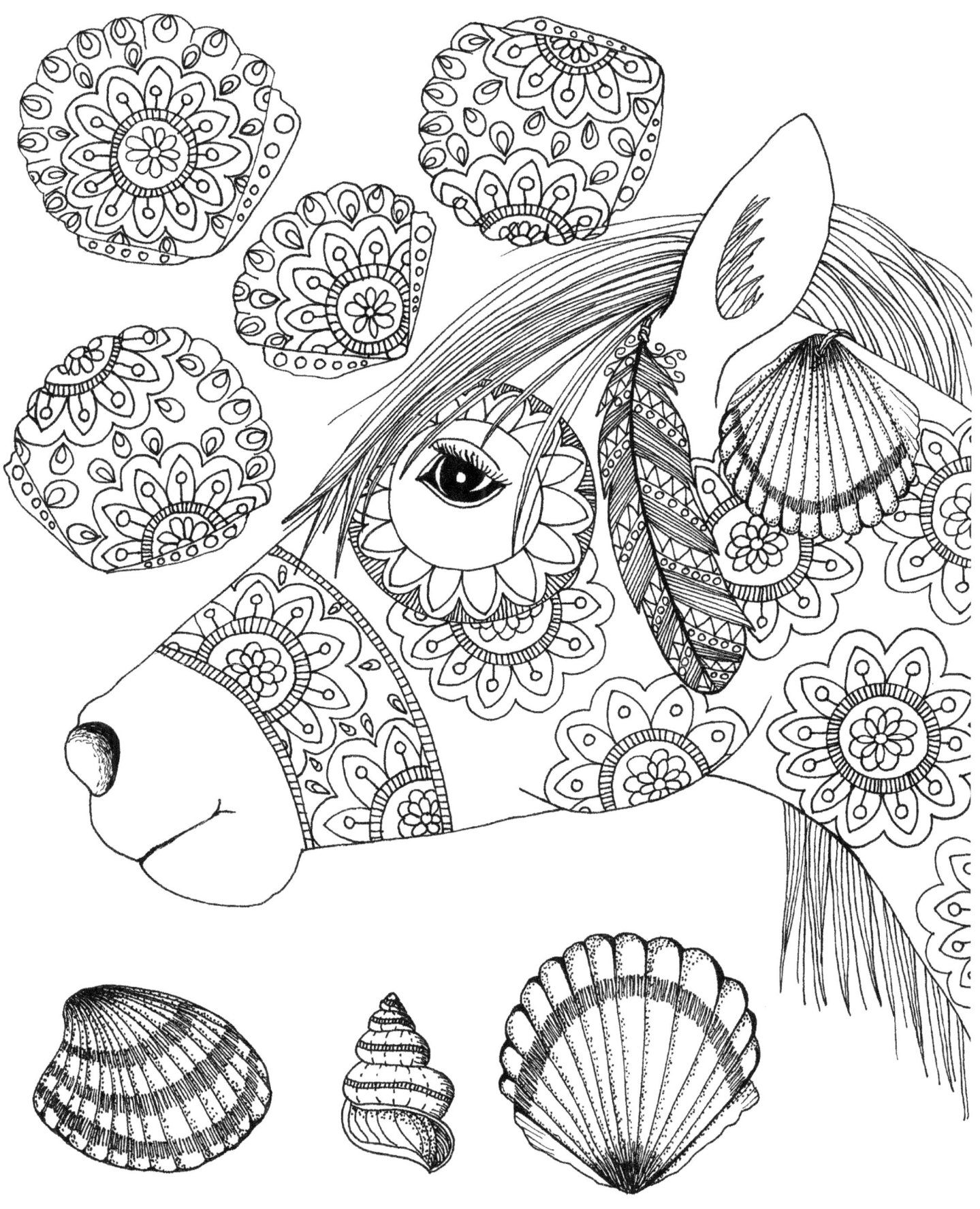

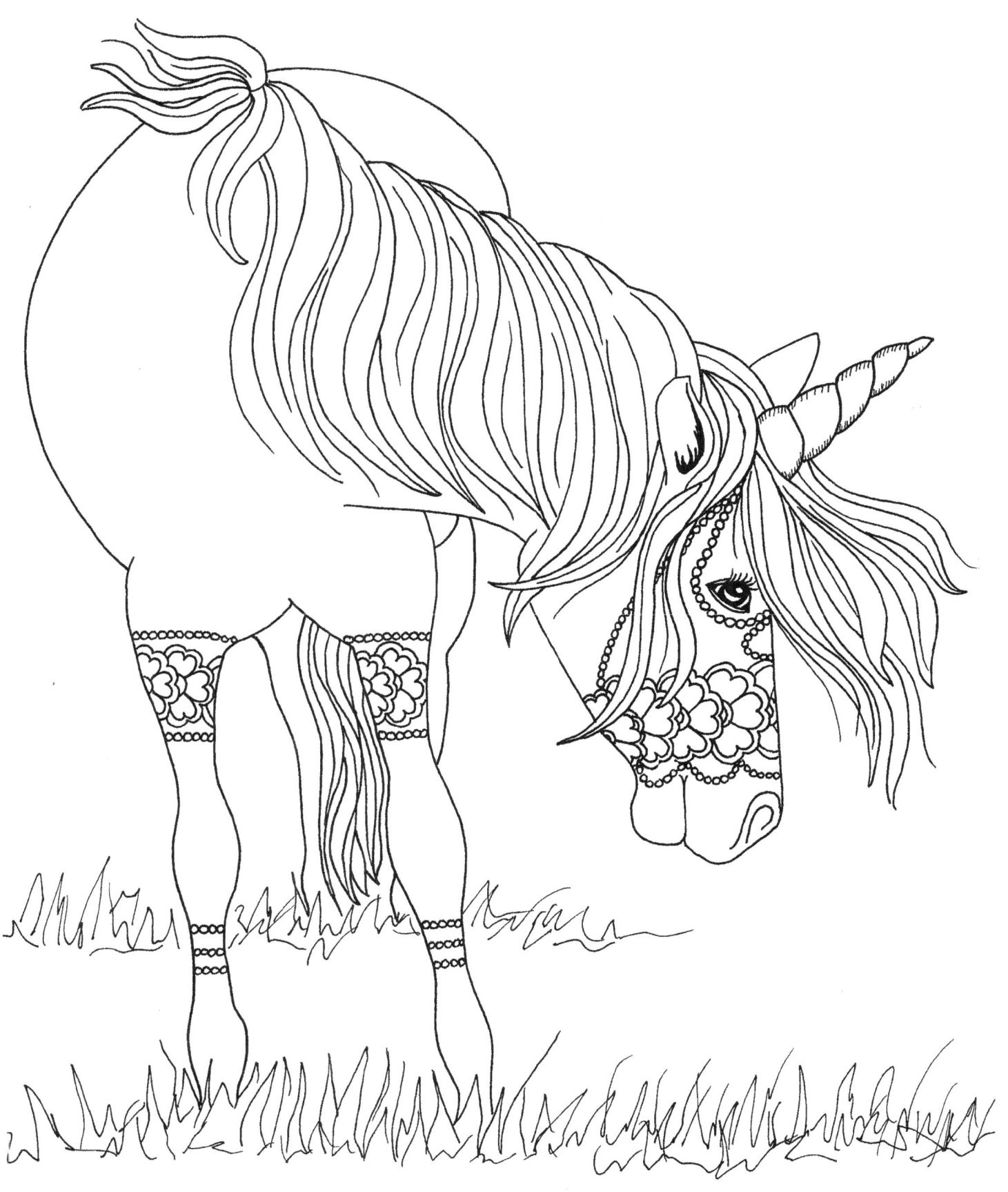

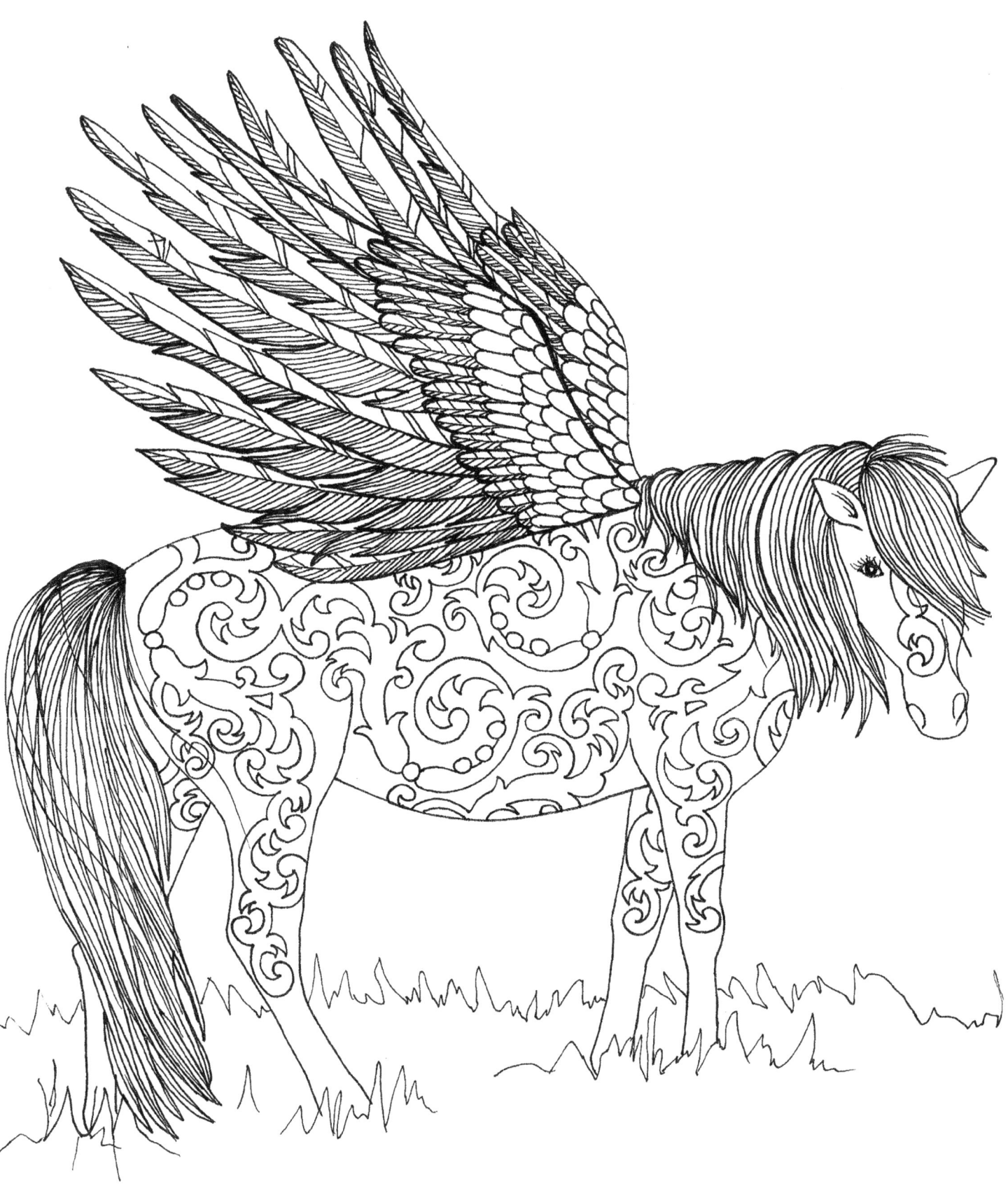

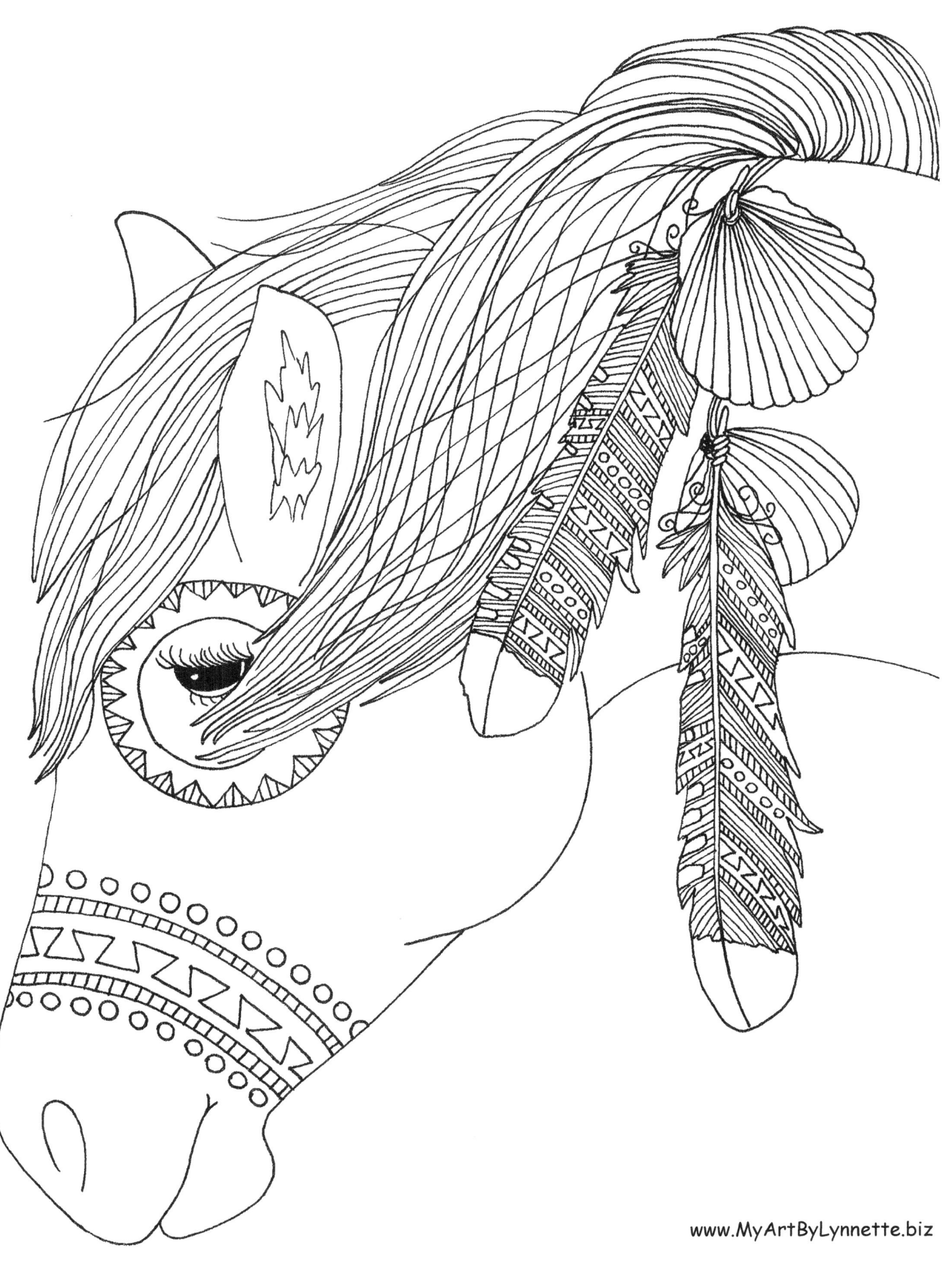

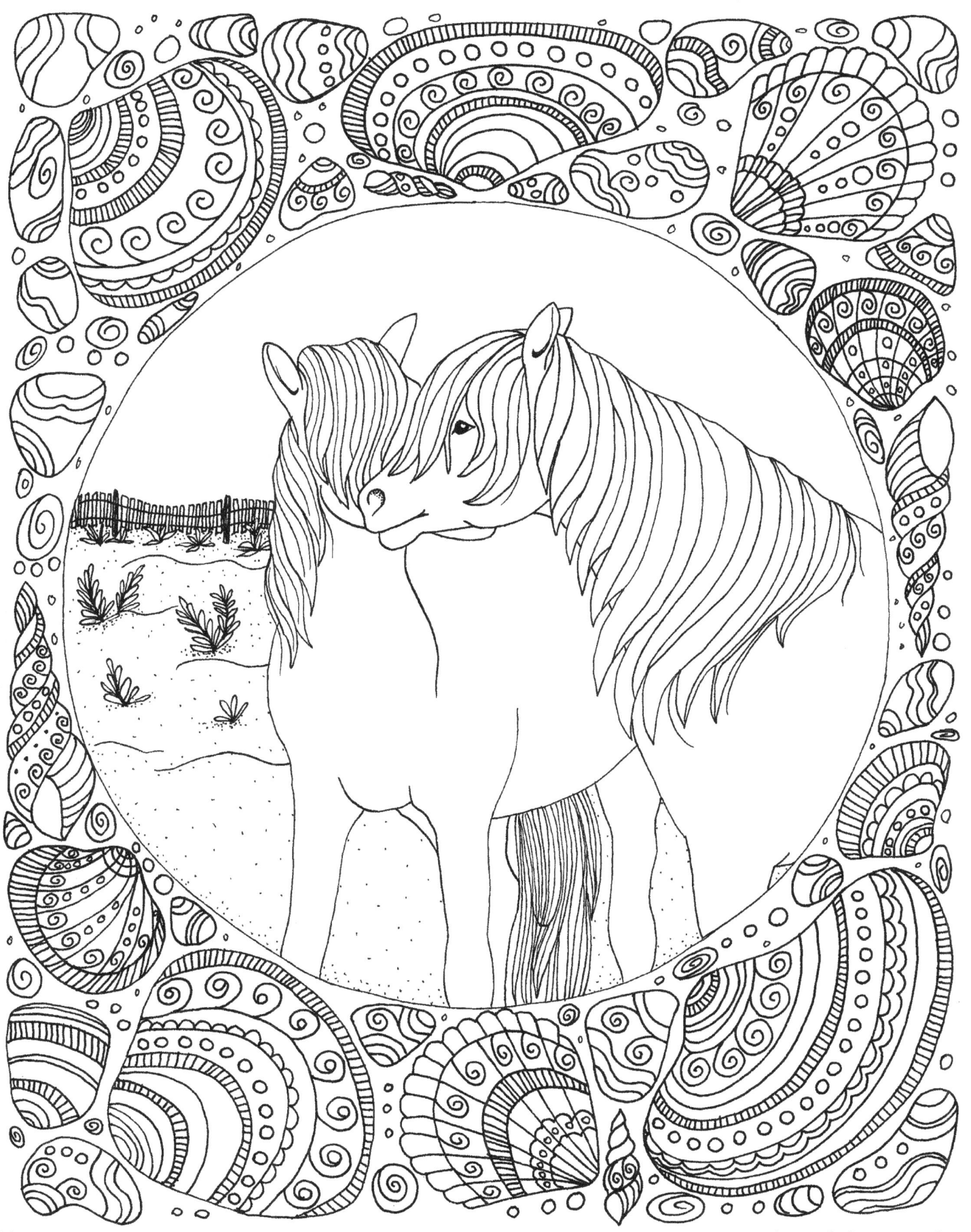

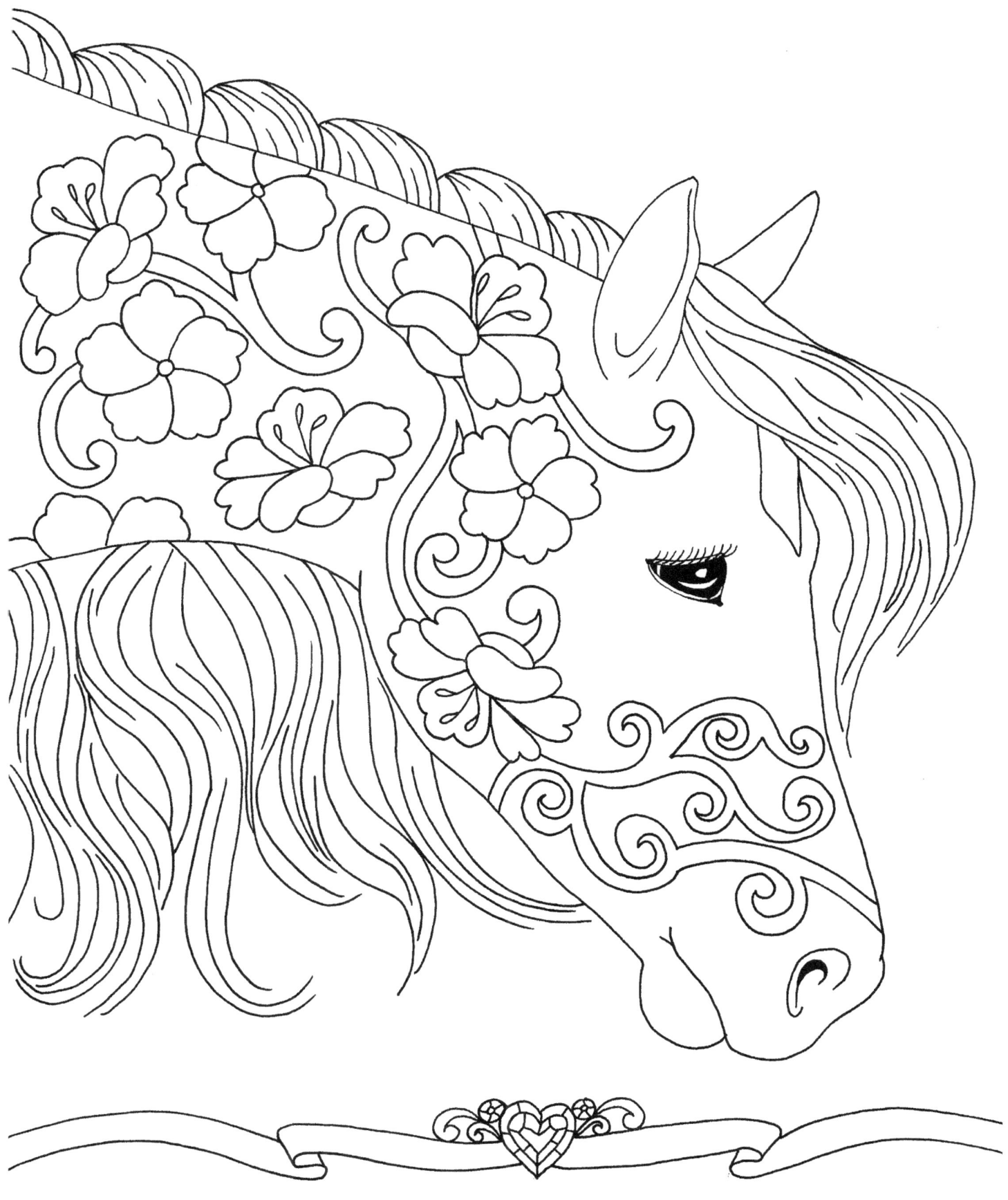

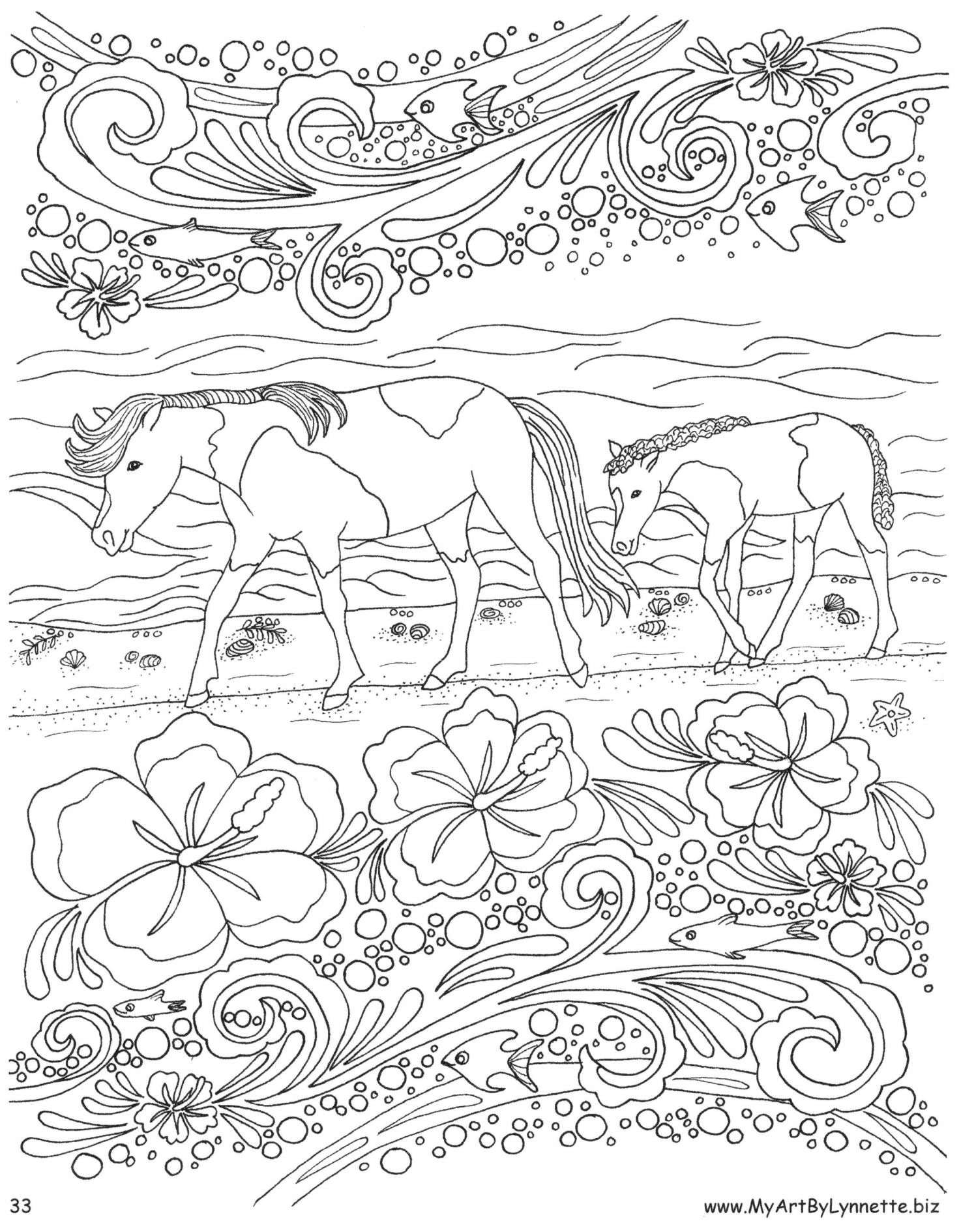

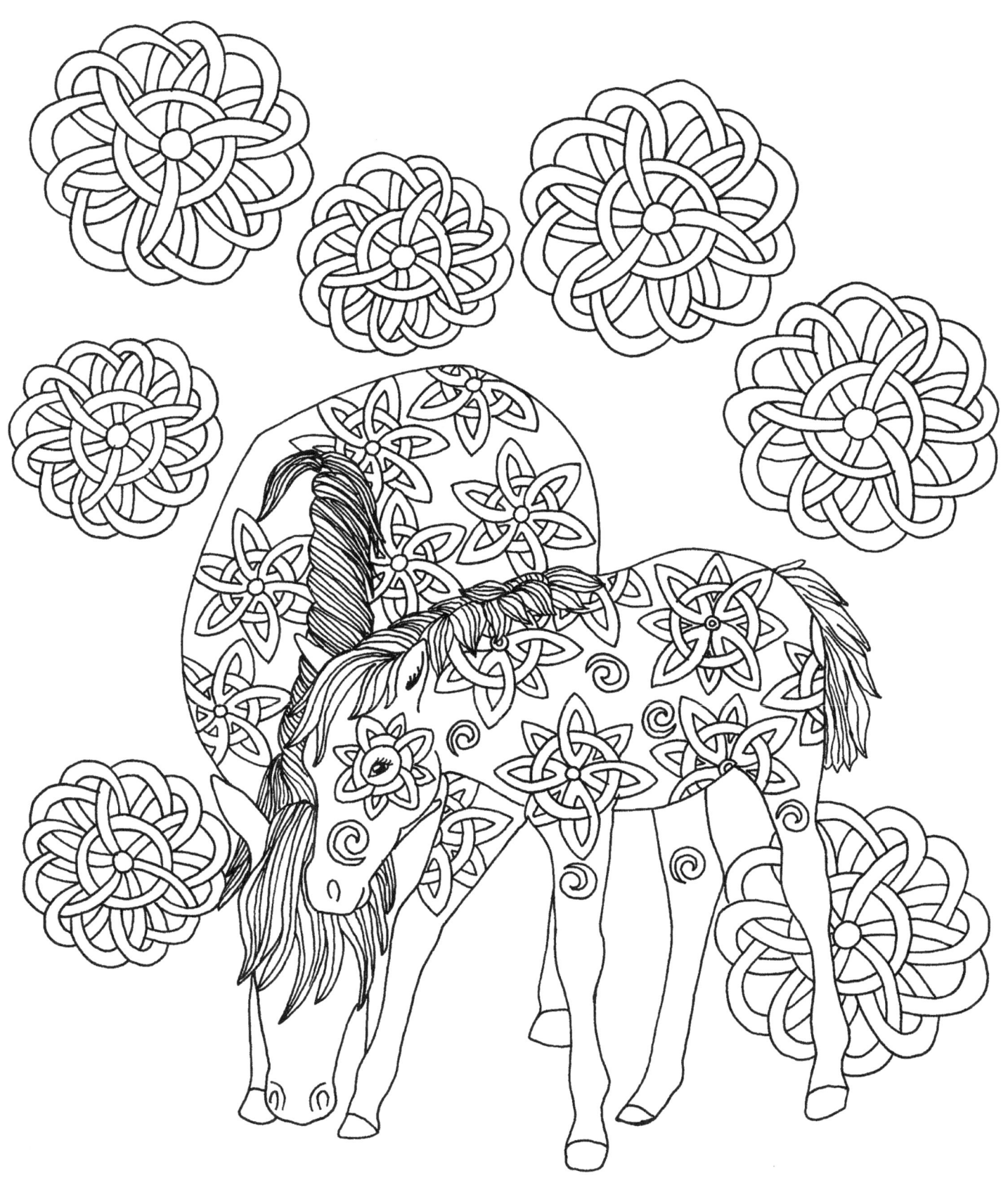

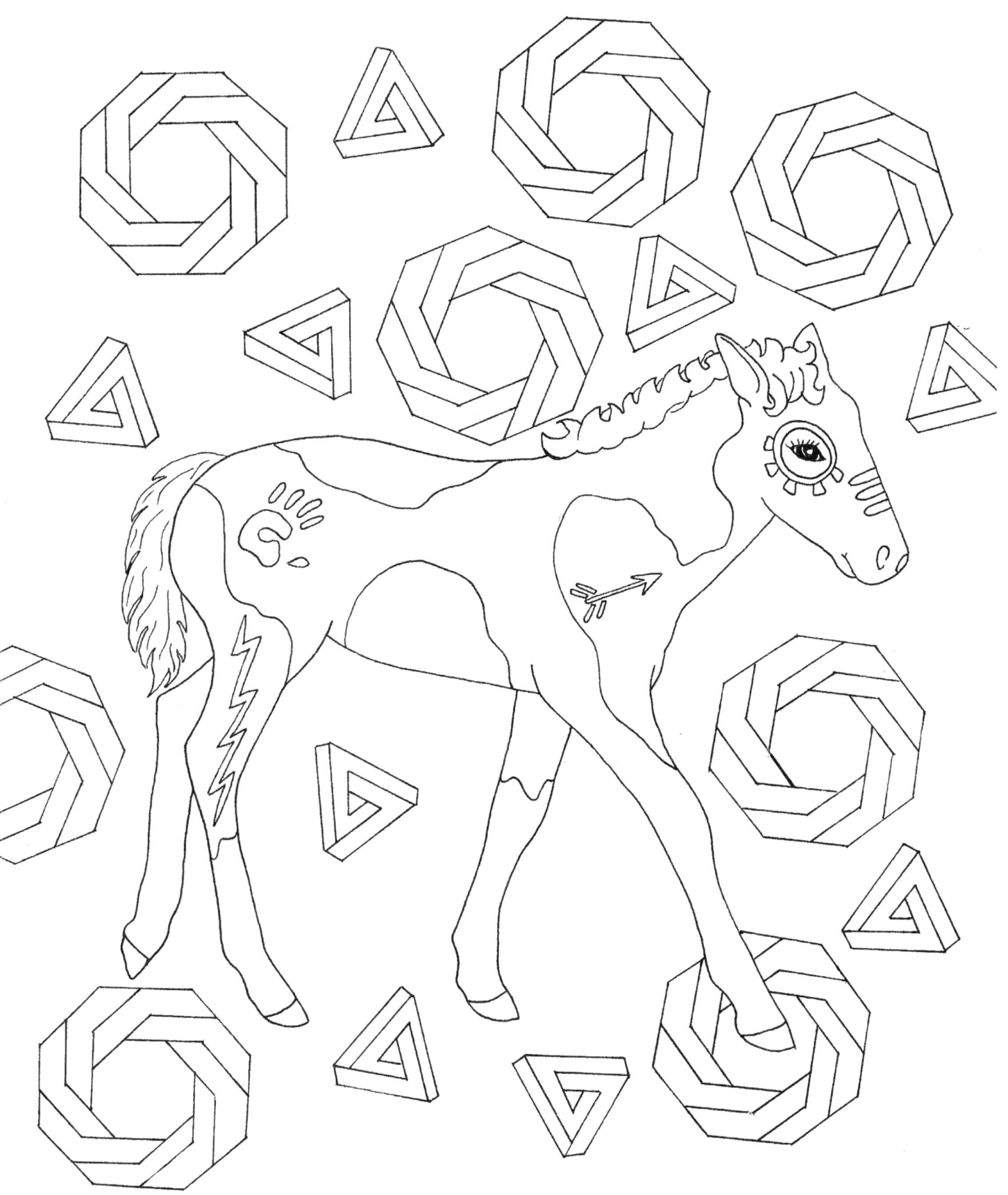

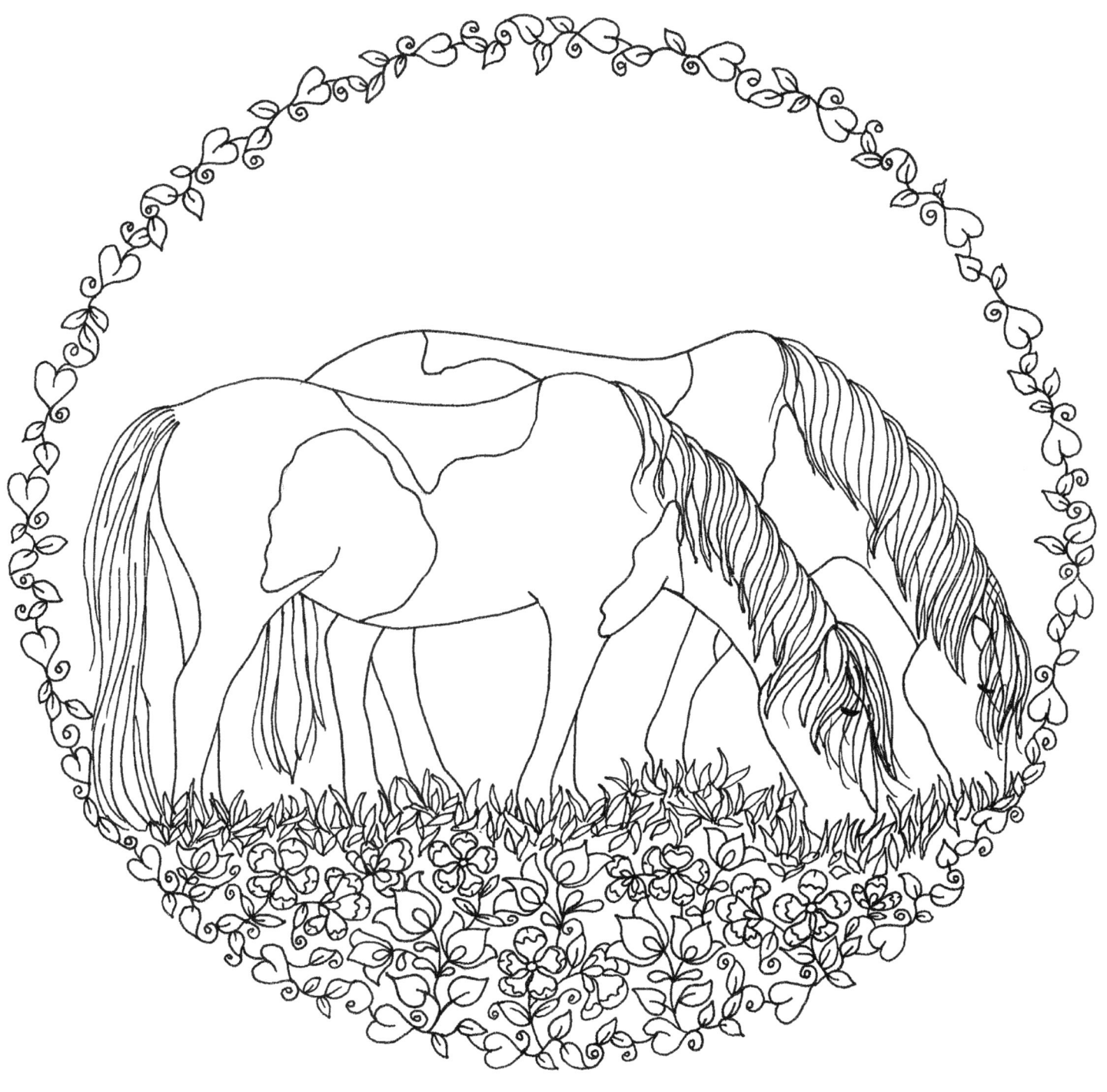

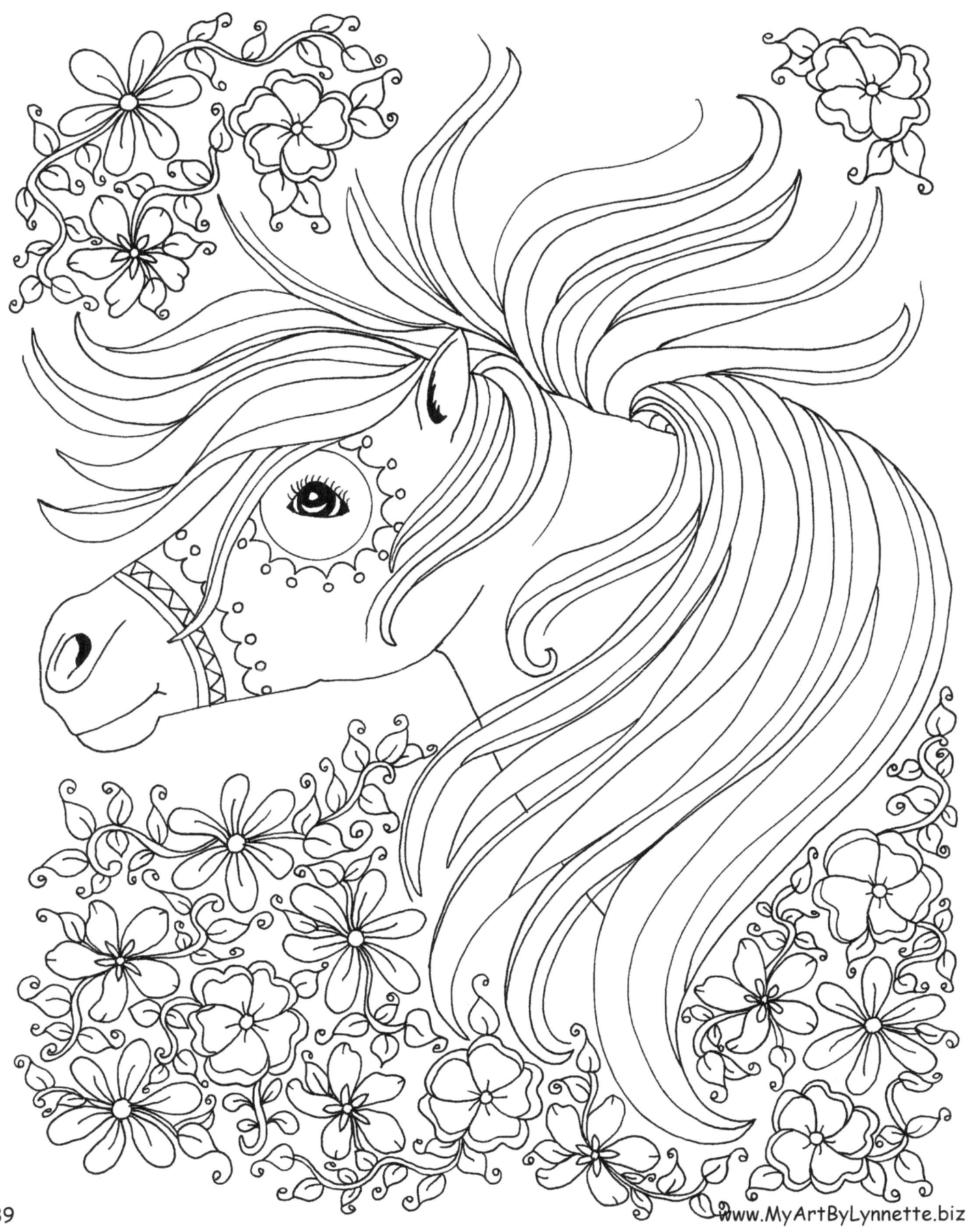

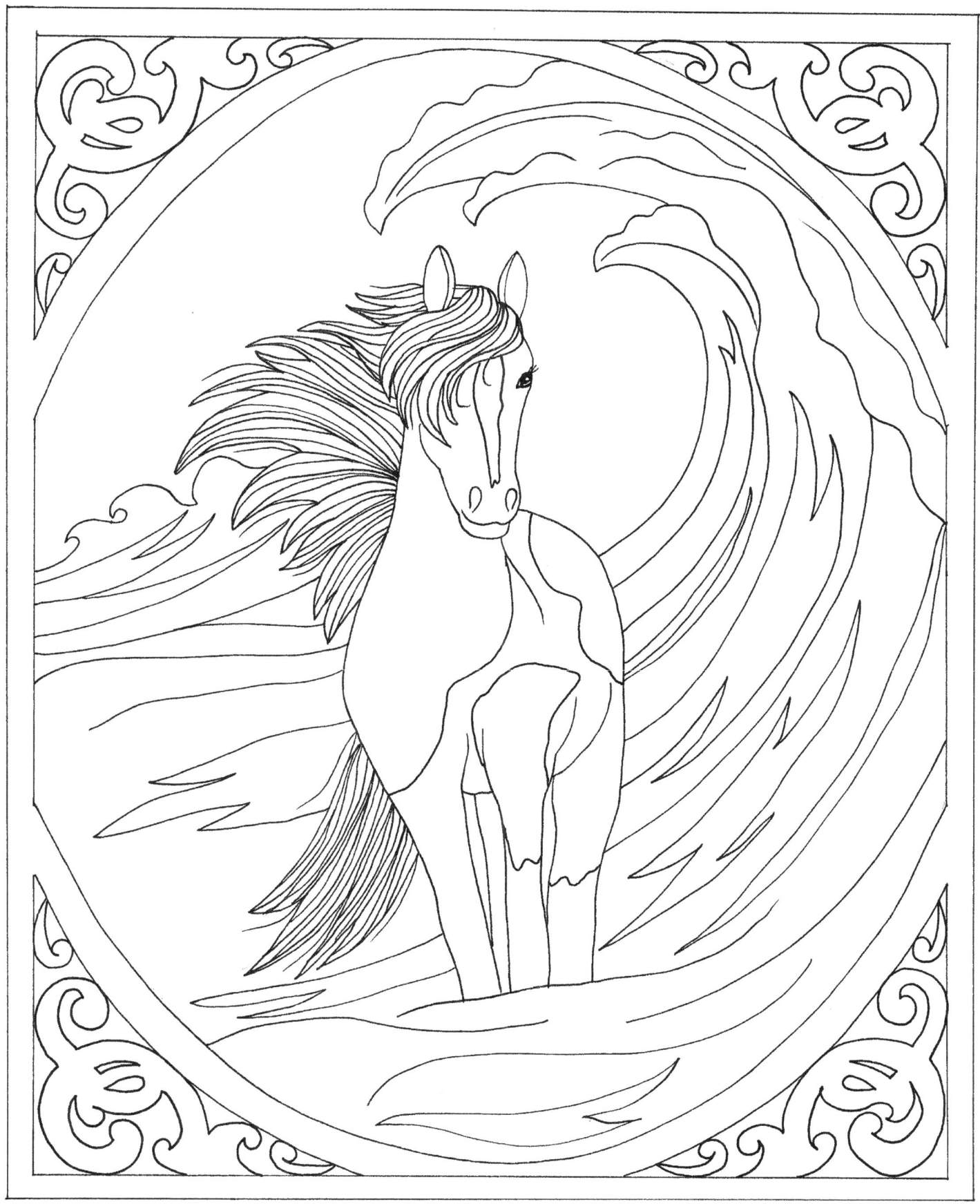

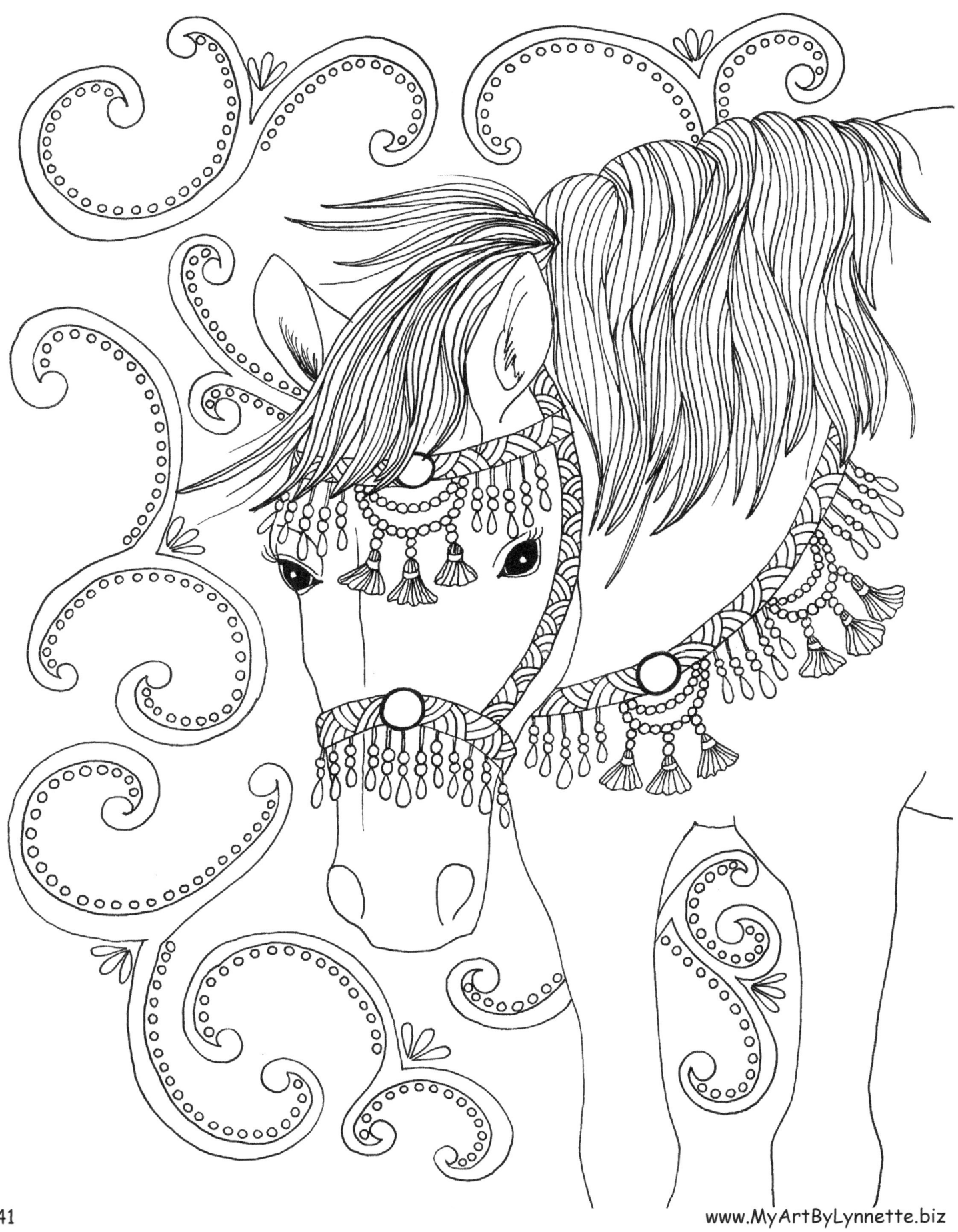

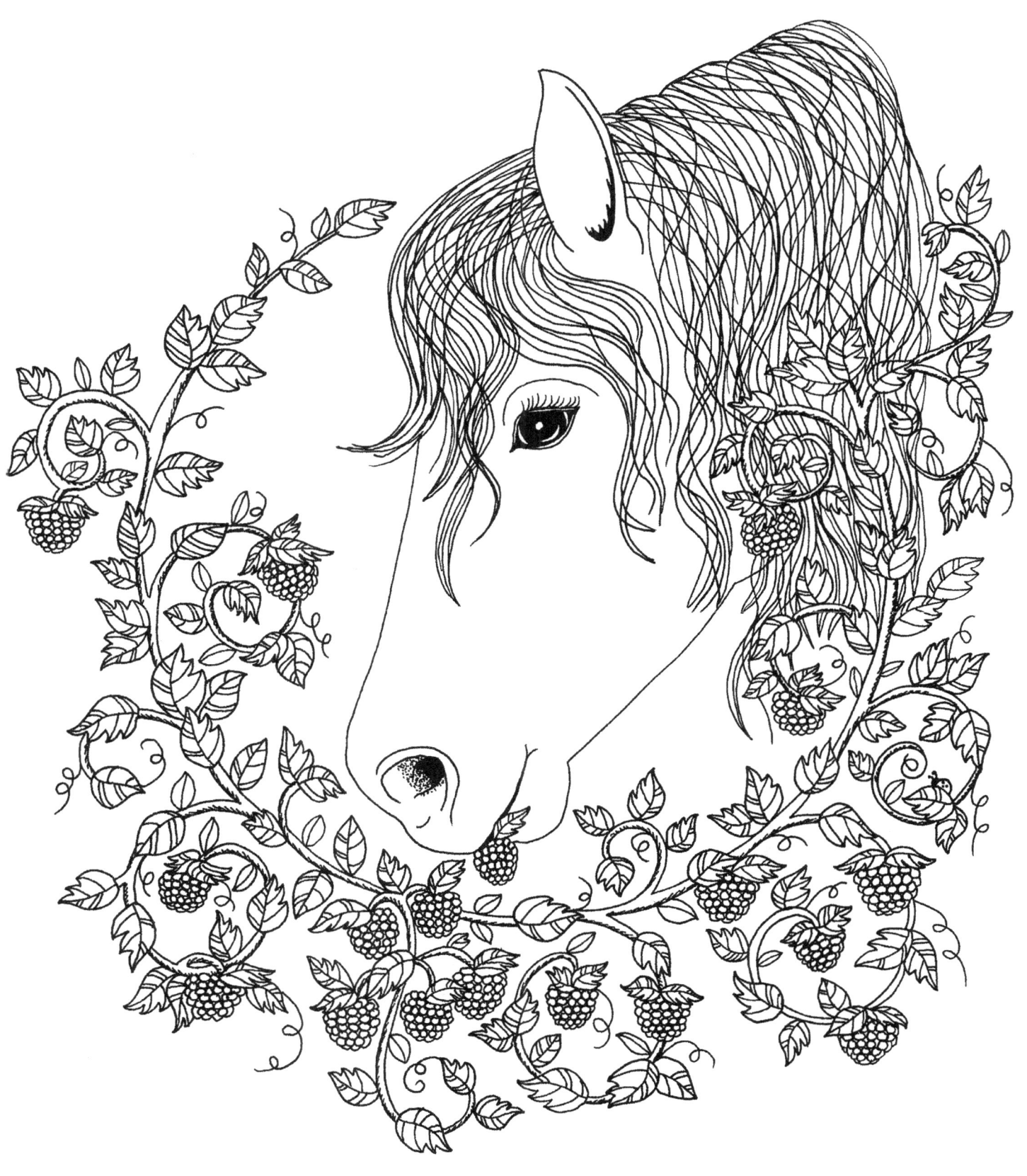

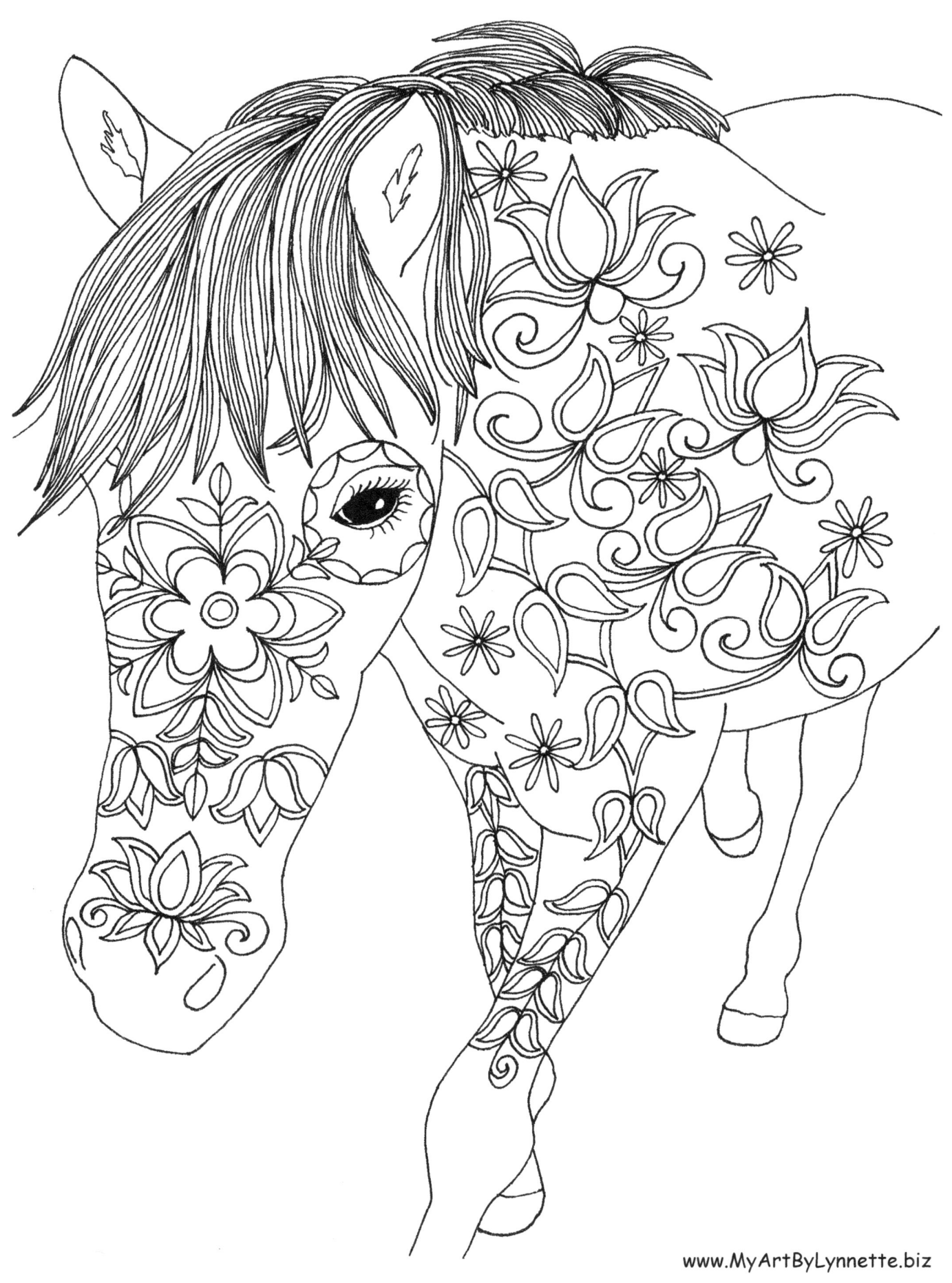

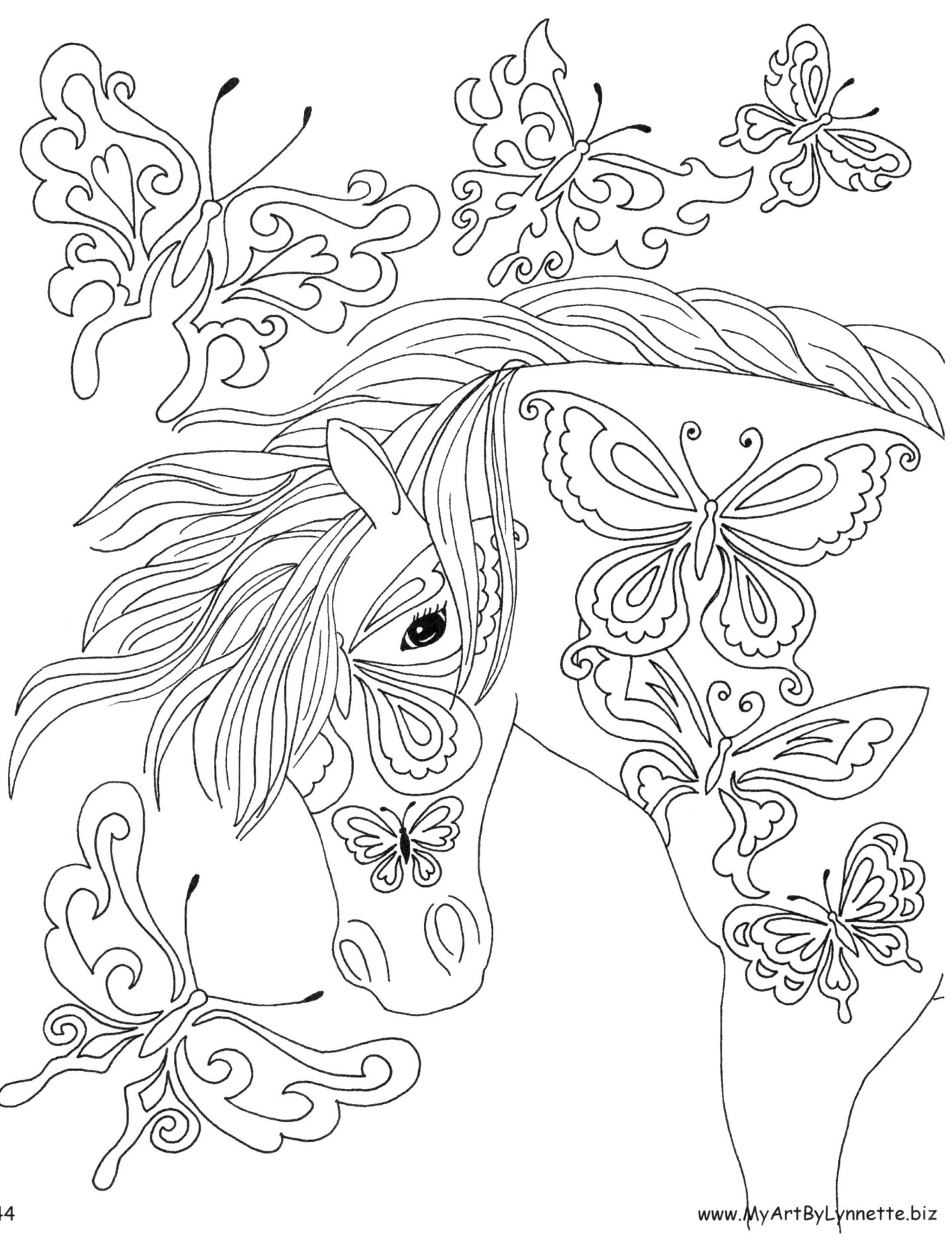

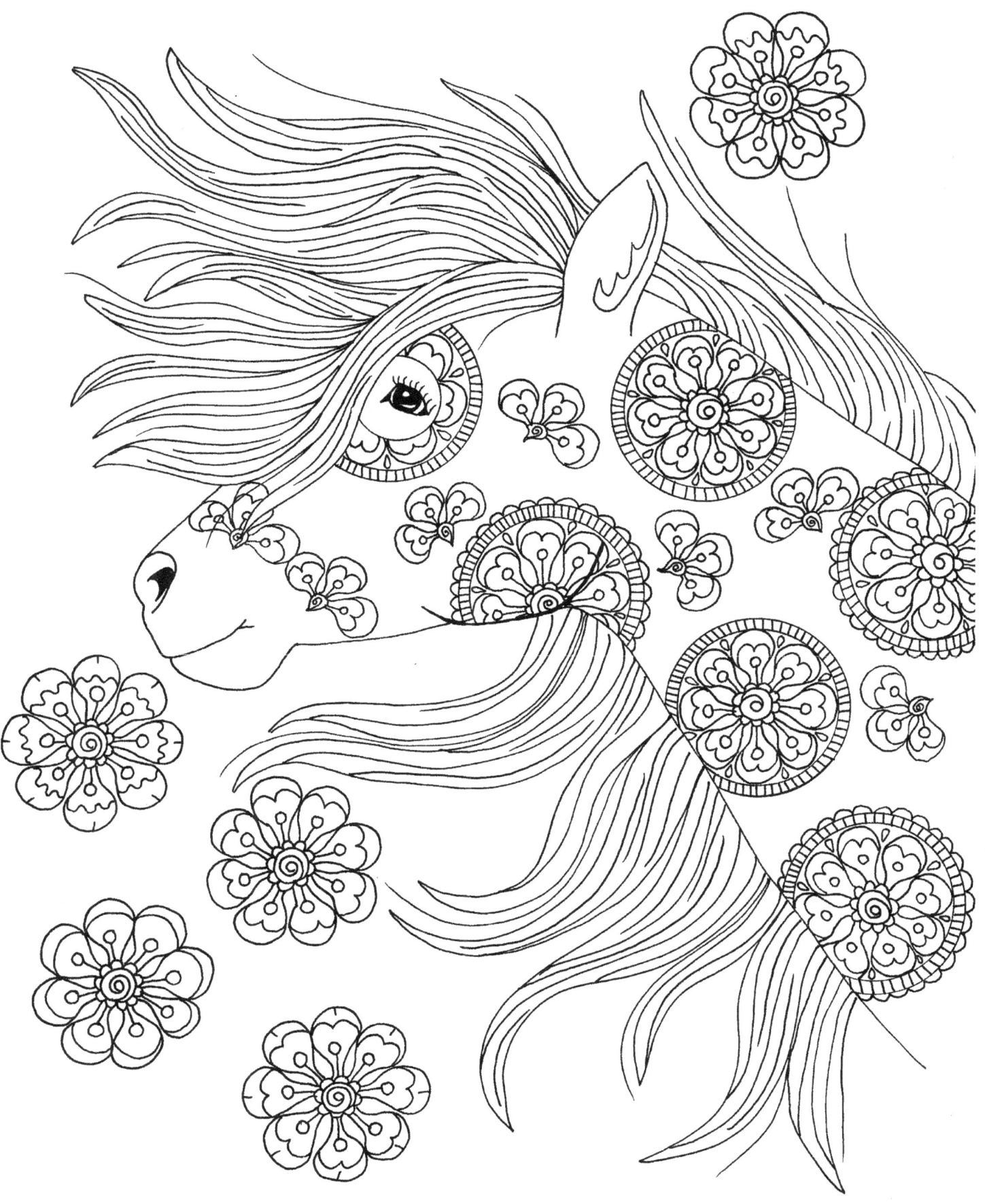

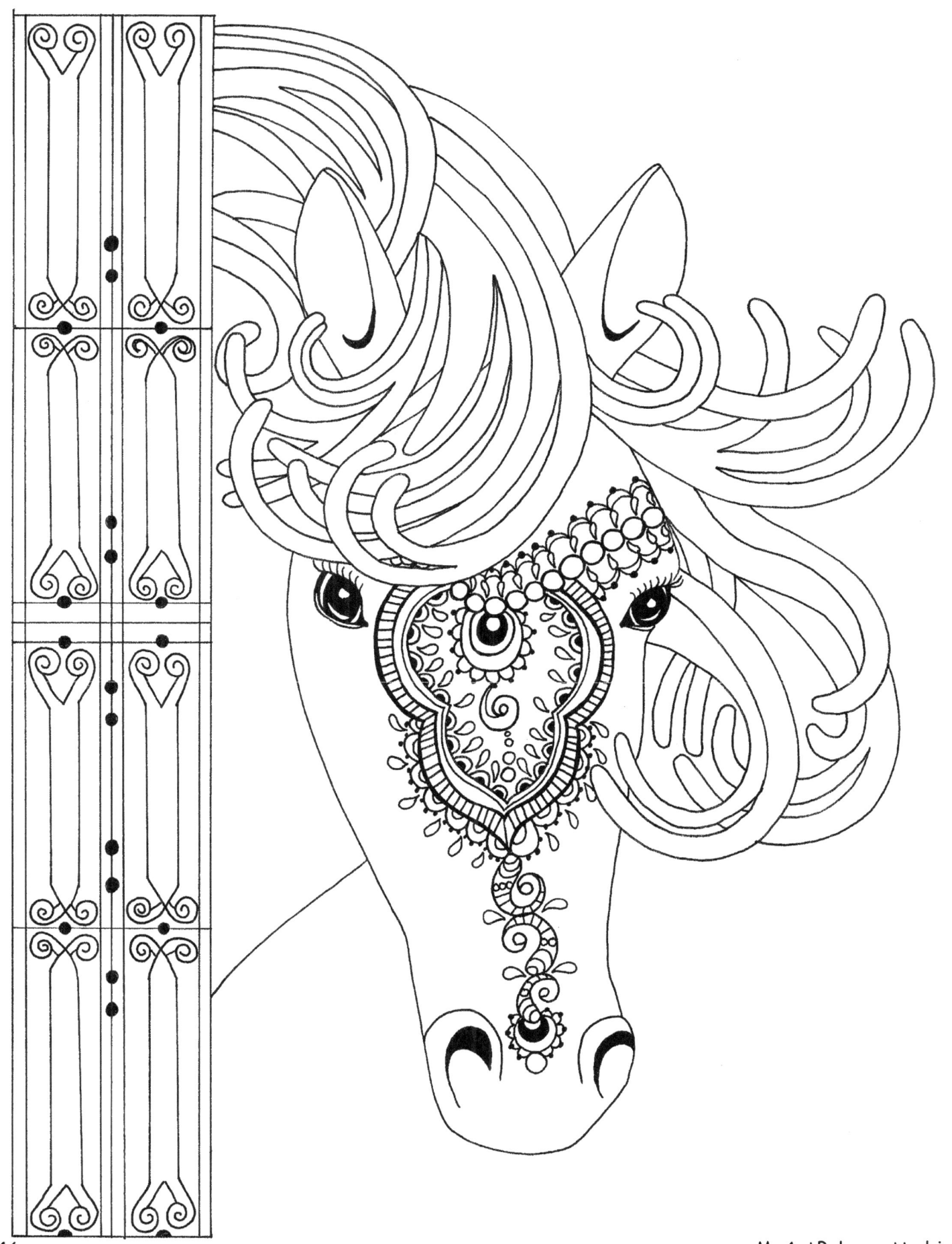

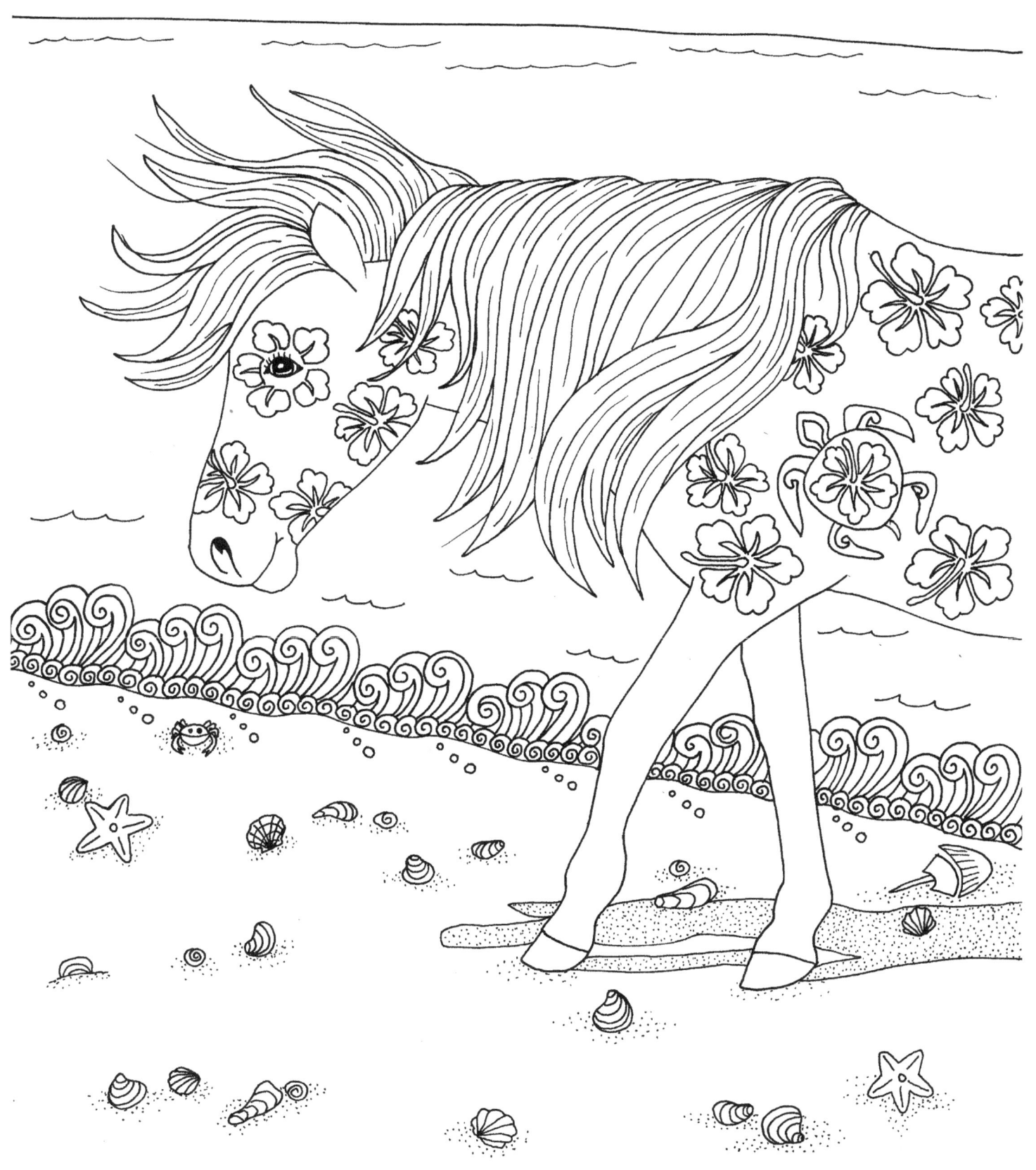

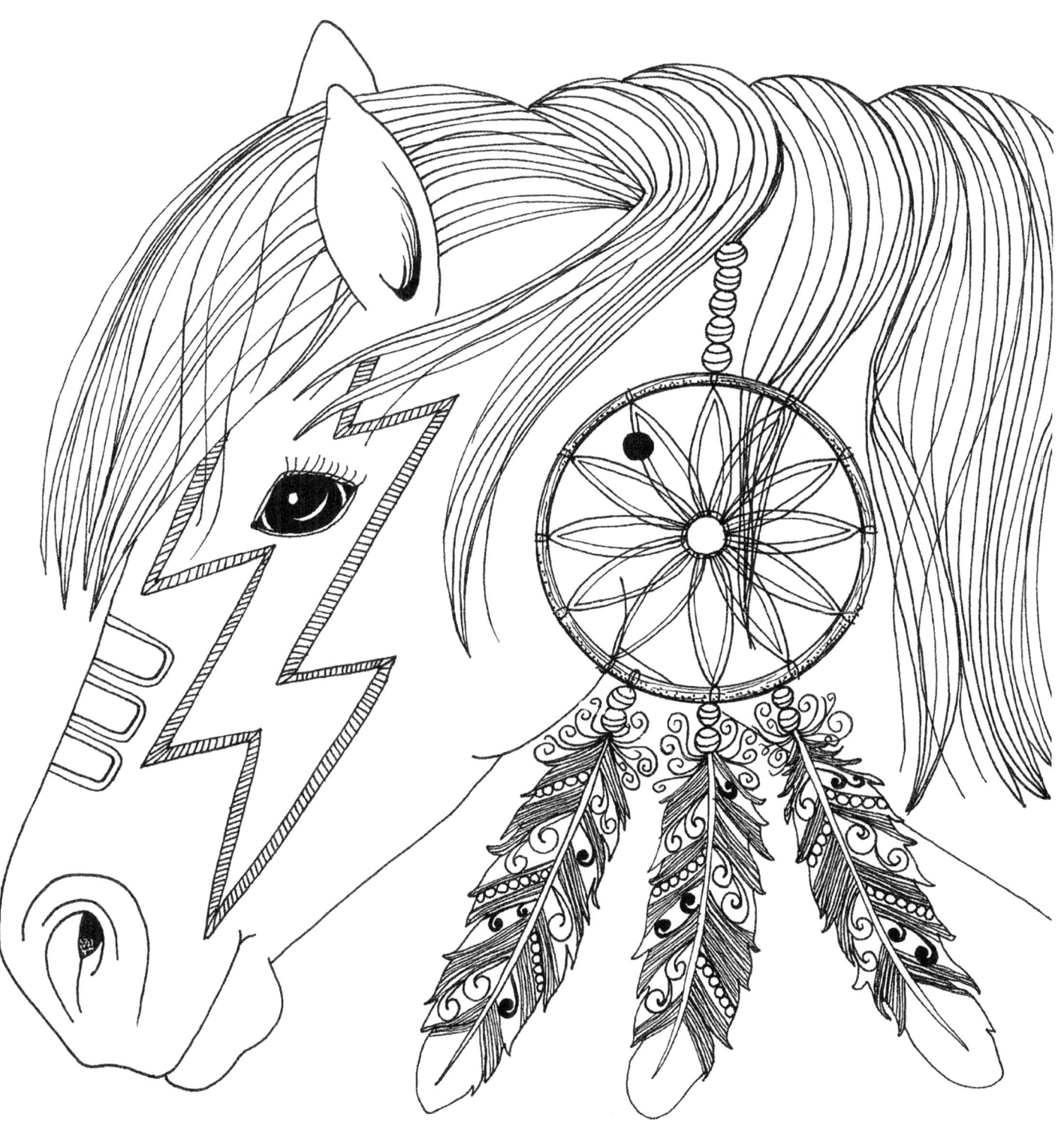

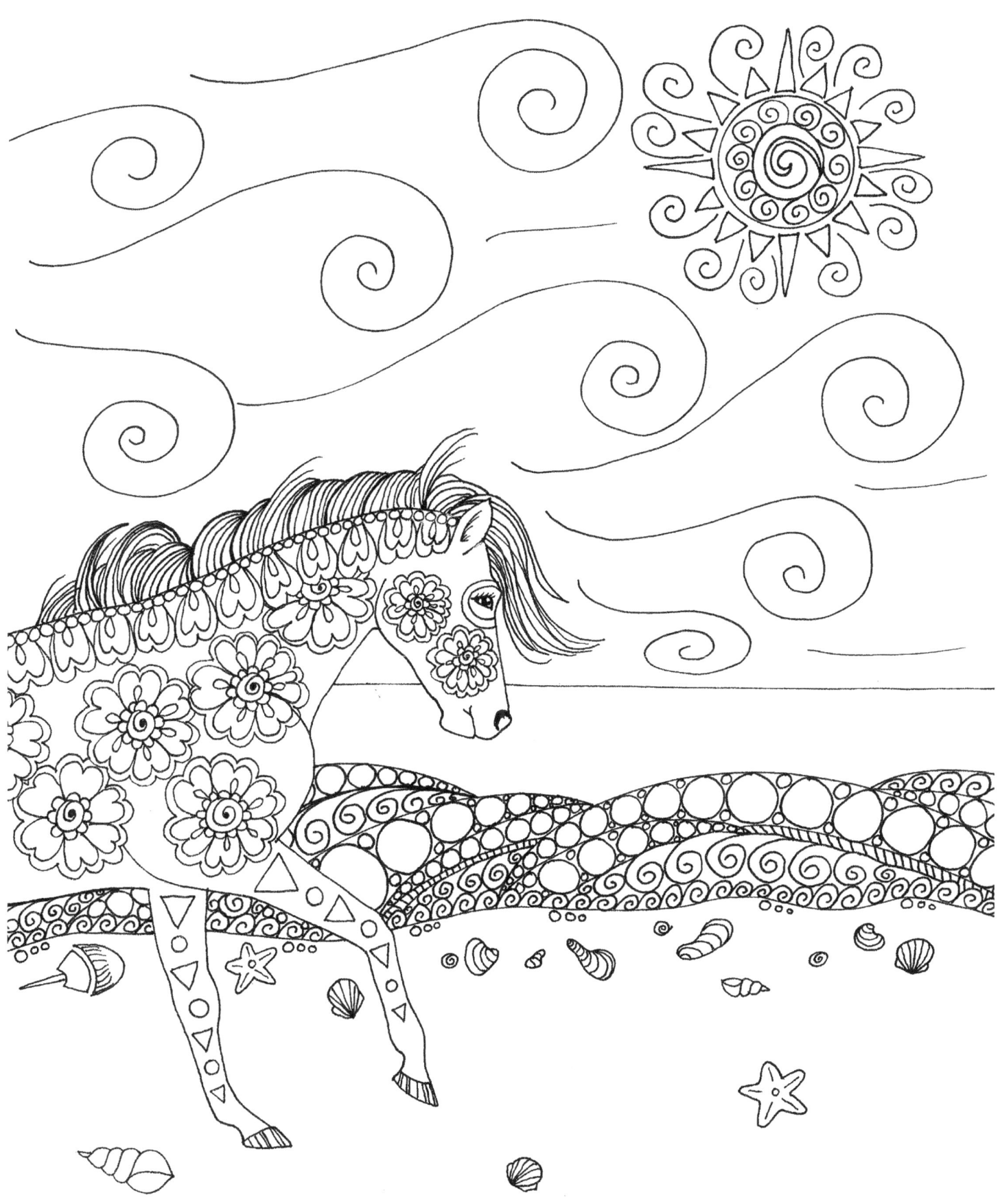

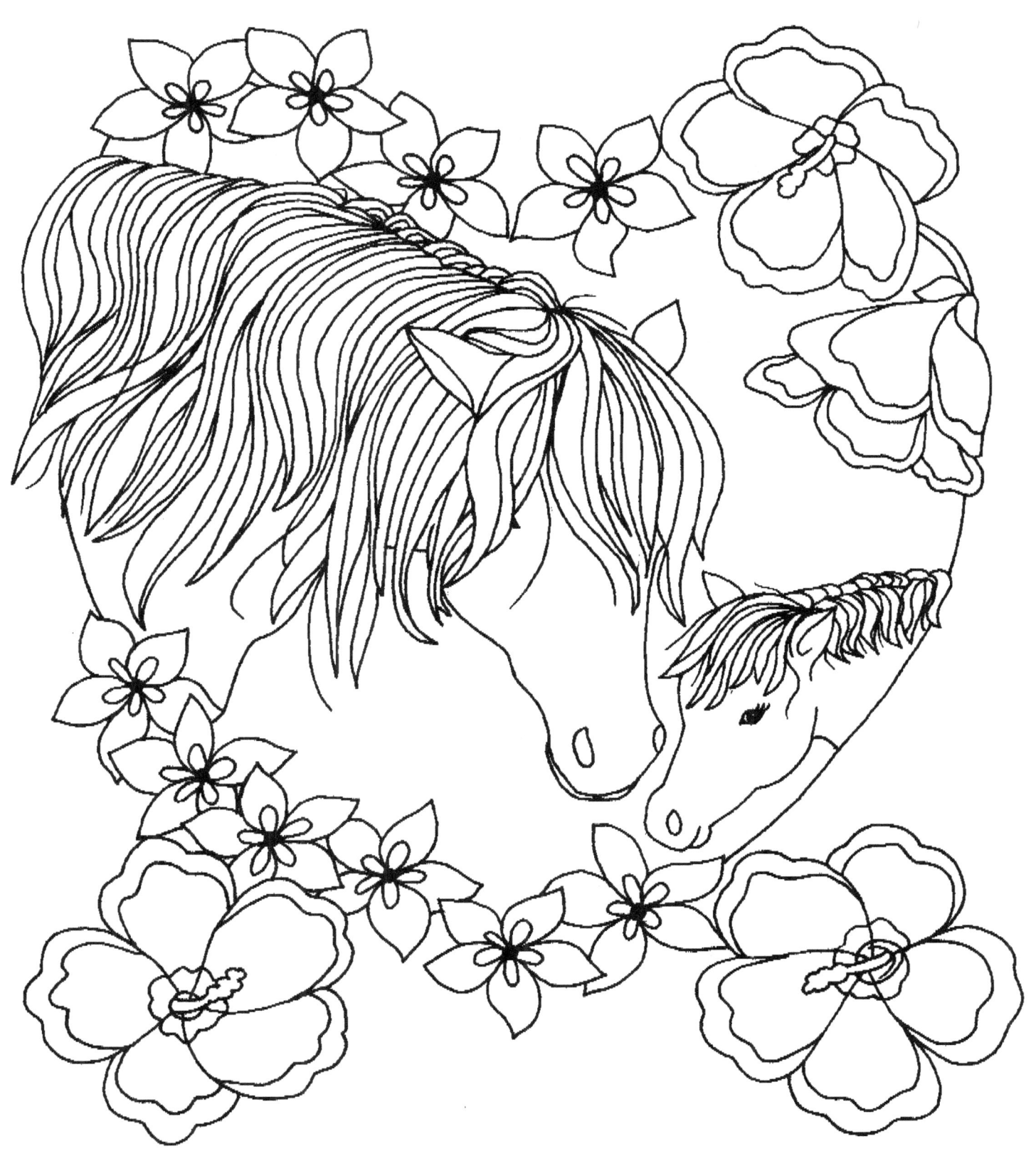

Thank you for choosing my coloring book.
I hope you are enjoying the illustrations that were drawn to share with you.

More Coloring Books by Lynnette Jones

My Butterfly Garden

My Cupcakes

My Ladybug Garden

My Heart Loves

My Kawaii Sweets

at www.MyArtByLynnette.biz